DOGS IN ANTIQ

Anubis to Cerberus
The origins of the domestic dog

Douglas Brewer
Terence Clark
Adrian Phillips

Aris & Phillips is an imprint of
Oxbow Books, Oxford, UK

© D. Brewer, T. Clark & A. Phillips 2001.
Reprinted 2011.

All rights reserved. No part of this publication may be reproduced or stored in a retrieval system or transmitted in any form or by any means including photocopying without the prior permission of the publishers in writing.

ISBN 978-0-85668-704-4

This book is available direct from

Oxbow Books, Oxford, UK
Phone: 01865-241249; Fax 01865-794449

and

The David Brown Book Company
PO Box 511, Oakville, CT 06779, USA
Phone: 860-945-9329; Fax: 860-945-9468

or from our website
www.oxbowbooks.com

A CIP record for this book is available from the British Library.

Printed in Great Britain by
CPI Antony Rowe, Chippenham and Eastbourne

Contents

List of Illustrations iv

Preface vi

Introduction 1

The Evolution of the Modern Dog (Douglas Brewer) 5
 notes 20

The Path to Domestication (Douglas Brewer) 21
 notes 27

The Dogs of Ancient Egypt (Douglas Brewer) 28
 notes 47

The Dogs of the Ancient Near East (Terence Clark) 49
 notes 79

The Dogs of the Classical World (Adrian Phillips) 81
 notes 104

Bibliography 107

Index 112

List of illustrations

1.1	Proposed family tree of the canids (after McLoughlin and Mathew)	6
1.2	Reconstruction of a Miacid (after McLoughlin)	8
1.3	Reconstruction of a Mesocyon (after McLoughlin)	8
1.4	Reconstruction of a Tomarctus (after McLoughlin)	8
1.5	A coyote	10
1.6	An African hunting dog.	10
1.7	A black-backed jackal	11
1.8	A dingo	11
1.9	A dhole	12
1.10	A wolf	12
1.11	Wolf skulls (after Wolfgram, Zuener)	14
3.1	An Egyptian sighthound (photo, The Egyptian Museum, Cairo)	29
3.2	Two Tesems	29
3.3	Cosmetic case (photo The British Museum)	30
3.4	Anubis (photo, The Egyptian Museum, Cairo)	30
3.5	A mummified dog (photo The Egyptian Museum, Cairo)	30
3.6	Petroglyph from the Eastern Desert with a hunting dog (photo D. Redford)	31
3.7	Petroglyph from the Eastern Desert of a dog with a bowman (Winkler, courtesy The Egypt Exploration Society)	31
3.8	Two Tesem hunting gazelle (photo The Egyptian Museum, Cairo)	33
3.9	A Saluki-type dog	34
3.10	A Saluki called 'Brave'	35
3.11	A Saluki chasing ostriches (photo Brewer, redrawn by S. Holland)	35
3.12	Three short-limbed hounds (after Newberry)	36
3.13	Short-limbed dogs	37
3.14	Mastiffs (after Quibell)	37
3.15	Mastiff (photo D. George)	38
3.16	A pariah (photo D. Osborn)	39
3.17	Diagram showing the shoulder heights	41
3.18	Diagram showing the shoulder heights (see Wapnish & Hesse)	42
3.19	Dog-headed gaming sticks (photo Metropolitan Museum of Art, Rogers fund, 1919)	47
4.1	The Arabian wolf (photo T. Clark)	51
4.2	Skeleton of a dog from Tell Brak (photo J. Oates)	52
4.3	Coins from Panormus (after Hilzheimer)	55
4.4	Stela of a mastiff in slips, The British Musuem (photo T. Clark)	56
4.5	Two modern Salukis in double slips (photo T. Clark)	56
4.6	Stone Achaemenid statue of a mastiff, Archaeological Museum Tehran (photo T. Clark)	57
4.7	Ashurbanipal's Mastiffs on leads, The British Museum (photo T. Clark)	59
4.8	Ashurbanipal's Mastiffs bringing down onager, The British Museum (photo T. Clark)	59

4.9	Assyrian war-dogs (after Hilzheimer)	60
4.10	A modern guard-dog in Iraq (photo T. Furness)	61
4.11	Gula's dogs (after Seidl)	62
4.12	Bronze figurine from Nineveh, British Museum (photo T. Clark)	62
4.13	The ancient hunt (photo T. Clark)	63
4.14	The modern hunt (photo T. Clark)	63
4.15	The hound (photo T. Clark)	63
4.16	Home from the hunt (photo T. Clark)	64
4.17	Huntsman with hound (photo T. Clark)	64
4.18	Home from the hunt (photo T. Clark)	64
4.19	Assyrian terracotta figurine, The British Museum (photo T. Clark)	65
4.20	Hounds on a fresco from Tiryns (after Hilzheimer)	66
4.21	Omani smooth feral hounds (photo T. Clark)	67
4.22	Seal impression of the hounds, Baghdad Museum	68
4.23	Detail from a beaker from Susa, Musée du Louvre, Paris	69
4.24	Detail of long-dogs on a beaker from Susa	69
4.25	Drawings of hounds hunting goats	69
4.26	Modern Saluki in Syria with cropped ears (photo T. Clark)	70
4.27	Rock engraving of a hound and attacking an ostrich (photo T. Clark)	74
4.28	Petroglyph of a Saluki (photo J. Lush)	74
4.29	A pariah dog in the Wadi Hadhramawt (photo T. Clark)	75
4.30	Stela of hounds attacking an ibex (photo T. Clark)	75
4.31	Detail from a mosaic in the Roman theatre Bosra (photo T. Clark)	76
4.32	Detail from a mosaic from Mount Nebo (photo T. Clark)	76
4.33	Detail from a mosaic from Mukhayat, Jordan (photo T. Clark)	76
5.1	Marble statue of the Molossian type, The British Museum (photo T. Clark)	81
5.2	Salukis going off to the hunt (photo T. Clark)	81
5.3	Detail of a roman mosaic from El Djem (photo T. Clark)	82
5.4	Detail from a fresco (photo Naples Museum)	82
5.5	'Maltese' dog (after Hilzheimer)	85
5.6	Two hounds of the Calydonian boar hunt (photo Florence Museum)	86
5.7	A hound of the Laconian type	88
5.8	A similar hound from a mosaic in North Africa (photo A. Phillips)	88
5.9	A 'cave canem' mosaics from Pompeii (photo Naples Museum)	90
5.10	Guard / Shepherd dog (photo T. Clark)	92
5.11	The cast of a guard-dog (photo Naples Museum)	92
5.12	A guard-dog chained to its kennel (photo T. Clark)	93
5.13	A pet dog (photo Fitzwilliam Museum, Cambridge)	94
5.14	A bundle of leads (photo A. Phillips)	99
5.15	A hound chasing a boar into a net (photo Bardo Museum, Tunis)	99

Preface

The inspiration for this book really belongs to Jaromir Malek whose book on Ancient Egyptian Cats appeared to require a reply on behalf of the canines. We gave complementary talks to an Egyptological society, Dr. Malek on the cats of Ancient Egypt and myself on the dogs. I was able to go one up only by introducing live specimens of ancient Egyptian Dogs in the shape of my two Salukis. Dogs appear much earlier in the Egyptian record than cats and are today much more diverse. One must also say in passing that the ancients wrote much more about dogs than about cats. The obvious person to write this book was Douglas Brewer who had already written a book on ancient Egyptian domestication which included a substantial section on dogs (Brewer 1996). He is well qualified as Director of the Spurlock Museum of Culture and Natural History and has directed excavations in Egypt. It then became clear that the investigation on the origins of our modern dogs would have to be extended to the Levant and the Near East and so Sir Terence Clark was asked if he would contribute on this area. As a diplomat he has travelled extensively in the Near East and paid particular attention to the native dogs in general and the Saluki in particular. He has written many articles in the specialist press and translated an early work in Arabic on hunting (*Al-Mansur's Book On Hunting*). To round off this brief study it then seemed appropriate to bring it up to date, so to speak, with the Graeco-Roman world. Having published a recent book on classical hunting and dogs (Xenophon & Arrian *On Hunting with Dogs*) this should have been a simple task but proved otherwise. Each of the authors has read and criticised each other's work but the views expressed in each chapter remain their own.

We wish to express our thanks to the Egyptian Antiquities Organization, British Museum, London and Cairo Museum for access to subjects photographed for this publication and for the provision of advice and written information. Art Wolfe Inc., Lew and Marti Ligocki/Impeccable Images, The Dog Breed Information Center, and The Dhole Conservation Project provided photos of the wild canids. Other photographs are acknowledged in the List of Illustrations. Imanuel Sampson and Steven Holland lent their artistic and computer skills to create many of the drawing. Special thanks are extended to Ann Hutflies for reading and commenting on numerous drafts of this publication and Richard Warga for much information on classical dogs.

AAP April 2001

Introduction

Unlike domestic cats, which have remained nearly uniform in size and shape over their history, domestic dogs range from the diminutive Chihuahua to the massive Irish Wolfhound. Today there are more than four hundred recognized breeds of dog and untold variants resulting from cross breeding. This book examines how the dog developed beginning with the evolution of modern canids. The domestic dog (*Canis familiaris*) is very ancient, going back to at least 9,000 BC (pp 25–7) and possibly much earlier. The domestication of cats (*Felis catus*) on the other hand, only dates from 3000 BC.[1] Although there are cat skeletons in Egypt from the Predynastic period that predate this time, it is by no means clear if they were domesticates, tamed wild cats, or simply wild animals living in and near the village. One of the reasons why domestic dogs appear so much earlier in the archaeological record than cats was their usefulness to humans. Because cats are territorial animals, they would have served little purpose to nomadic peoples. Once people settled into an agricultural lifestyle, however, cats would have attached themselves to villages, serving as mousers.

While cats have maintained their original role of pest control, dogs have been employed in many different ways. Whether dogs first appeared as camp scavengers, hunters, or for their ability to guard is a matter of speculation and a question that by its nature cannot be determined from the fossil record (Chapter II). But in addition to these functions, dogs have been used since ancient times for a multiplicity of other purposes: herding sheep and cattle; as draught animals; as rescuers; as food; as soldiers; as guides; etc. The list is almost endless, as dogs have been intimately associated with humans in every aspect of life, at home, in the field, at work and at play. It is perhaps the diversity of the tasks that the dog has been required to perform that has resulted in so many different breeds. Another factor is geography. A dog that has to survive the arctic conditions of the tundra such as the Husky must have a very different physique from one that comes from the tropical south such as the Basenji.

The majority of modern breeds are predominantly European in origin, though they have spread to all parts of the world and likewise now come from all parts of the world. How did this happen? When did dogs first appear in the human record and how did they develop into such diverse breeds? These are the questions that this book attempts to answer. Most contemporary breeds are of relatively recent origin and even those of considerable antiquity such as the spaniels can only be traced back with any degree of certainty to mediaeval Europe. A few breeds such as the Saluki and greyhound are known from Ancient Egypt and Mesopotamia

but few other breeds can attest to such antiquity. When looking for the origins of modern breeds it seemed sensible to concentrate on those areas from which we have the earliest and most complete information, notably Egypt and the Middle East, which saw the birth of the earliest urban civilisations. (The influence on modern western dog populations of the other ancient civilisations such as China or the Indian sub-continent is much more recent.) The direct successors to the rulers of Egypt and the Middle East were the Greeks — or more accurately the Macedonians — and then the Romans to whom Europe owes so much of its thought, culture and material civilisation. It is to these ancient peoples, perhaps, that we owe the spread of the breeds into such a wide area.

The results of scientific investigations are never final; theories are never proved, only disproved. The results of investigations into the origins of the modern dog are no exception. The overwhelming evidence to date, however, points to the wolf (*Canis lupus*) as the sole ancestor of the domestic dog (*Canis familiaris*). This evidence, including anatomy, behaviour and genetics, is examined in some detail in Chapter I. The next chapter looks at the processes of domestication and the development of the earliest breeds.

The earliest evidence for domestic dogs comes from the Near East. Early remains from Europe are very scarce and difficult to interpret (p. 26). But it is noteworthy that there are no dogs in the prehistoric cave paintings at Lascaux, and there is no suggestion from anywhere in Europe that dogs were domesticated before about 7,500 BC. For example, canid bones have been found in the Pyrenees, an area particularly rich in prehistoric sites, but none date before then.[2] This explains why Egypt and the Middle East are central to a study of the early dog. Although good evidence from preagricultural (c. 7,500 BC) contexts exists in the Middle East, it is important to note that the body of evidence increases rapidly in the Neolithic period. As cultures diversified and adapted to different ecological niches, so too did the dog. Although in some cases humans may have regarded dogs as a food source, humans probably exploited the earliest domestic dogs for their innate tendencies to guard territory. It wasn't long, however, before the dogs' high level of intelligence and adaptability revealed that they could learn and perform more complicated tasks.

The earliest dogs in the Ancient Egypt probably entered via the Sinai land bridge, though they may also have come across the Red Sea from Yemen or even from Somalia.[3] By whichever route, this happened a very long time ago — at least six or seven thousand years ago when the climate was certainly different from today and the desert areas much more fertile and able to sustain humans and animals. The rock drawings in the Sahara, which are around six to seven thousand years

old, show water-loving animals that have long since disappeared from those arid regions. An enormous amount of material both zoological and archaeological has been preserved in Ancient Egypt. On the basis of an examination of the physical, artistic and written records, Chapter III discusses what is known about dogs in ancient Egypt, including various breeds and their diverse functions.

Chapter IV explores what we know of the dogs from other areas of the Middle East. The material is less abundant and more difficult to interpret than the Egyptian data, but it is very early and contains the oldest known remains of dogs that were certainly domestic. It is also consistent with what we know from Egypt.

Further information comes from the classical period when the expansion of the Greek and Roman empires included both Egypt and much of the Near East and eventually the whole of North Africa and Southern and Central Europe as far north as Britain and the Rhine. To the archaeological and zoological record we can then add the writings of the Greeks and Romans on hunting and on dogs (Chapter V). It is the Roman Empire with its belief in the inclusiveness of its citizens whatever their origin that links the three areas of our quest for the origin of the modern dog.

While scientific and archaeological discoveries are constantly extending the frontiers of our knowledge and we already have a large body of information on the early development of dogs, with a few notable exceptions such as the Saluki, we are not yet in a position to make definite links between ancient dogs and modern dog breeds. In view of the nearly two thousand year gap between the ancient world and ourselves this is hardly surprising. The Romans, for example, mention British dogs and some of their characteristics but the intervening dark ages and the later mediaeval illustrations and writings do not, as yet at any rate, permit any clear connections with modern breeds.

Similarly, discussion about whether dogs, like horses or camels, come from further east than Mesopotamia is largely speculative as we have no clear and dateable evidence that is older than the Egyptian or Middle Eastern, though some pictorial representations from Central Asia go back as far as the 5th millennium BC.[4] Thus if sight-hounds, for instance, originated in a nomadic society of Central Asia we have yet to discover the evidence. This book focuses on those parts of the puzzle that are known or for which we have evidence upon which to base some reasonably plausible explanations. We have deliberately excluded the rest of Asia including the Indian sub-continent and China, the Americas and Australasia because beyond casual mentions in the classical literature (p. 104)

their canine influence on modern breeds before the nineteenth century cannot be evaluated by the current state of our knowledge.

With new techniques of genetic research, a much more complete picture of the relationships between the world's diverse dog populations may emerge. Yet current genetic research is not without problems. Results of some genetic studies have suggested that the domestication of the dog may date back as far as 130,000 BC, yet none of the other evidence — whether from artefacts or fossils — puts domestication earlier than 10,000 BC. As these new techniques are refined, the picture will likely change, but this book summarises the present state of our knowledge about the most successful terrestrial species next to humans.

Notes

1 Brewer 105-9.
2 Bahn 227.
3 Brewer 114, Przezdiezski.
4 Przezdiezski.

CHAPTER I
The Evolution of the Modern Dog
Douglas J. Brewer

To trace the early history and origin of the dog, one must turn to the fossil record of its canid cousins. Unfortunately, like all palaeontological records, the canid fossil record is inconsistently preserved and has gaps in the evidence. In addition, different interpretations of recent finds have led to scholarly debates about how to include the new data within established family trees. Nonetheless, there has been a general consensus on the evolution of the canid family since the 1930s[1] and, while new palaeontological and genetic evidence may yet effect fine-tuning, the model itself may be presumed to be sound (fig. 1.1).

The earliest fossil carnivores that can be linked with some certainty to the canids are the Eocene miacids, 55-38 million years ago. All miacids possessed relatively large brains for Eocene mammals and all had five-toed plantigrade feet. That is, they walked on the full soles of their feet like bears and humans. Miacids, with their short limbs and long and sleek morphology, resembled modern mongooses or weasels (fig. 1.2). From the miacids evolved the cat-like (Feloidea) and dog-like (Canoidea) carnivore. Most important to the ancestry of the dog was the Canoidea line that led from the coyote-sized Mesocyon (fig. 1.3) of the Oligocene (38-24 million years ago) to the fox-like Leptocyon and the wolf-like Tomarctus (fig. 1.4) that roamed North America some 10 million years ago (Miocene). From the time of Tomarctus, dog-like carnivores began to expand throughout the world.

It is believed that, like the horse and camel, the wild ancestor of modern dogs originated in North America then crossed the Bering land bridge and quickly spread across all of the world's continents except Australia and Antarctica, both of which were isolated from canid expansion until the coming of humans. This ability to adapt to a variety of ecosystems — enhanced by their speed, intelligence, and ability to revert to plants as a food source if the need arises — ranks canids second only to humans as the world's most adaptable and widespread terrestrial mammals.[2]

Today the family Canidae, which includes the domestic dog, is a diverse group of 16 genera and 36 species[3] that vary in size and proportion from tiny, squat Chihuahuas to long-legged maned wolves. Characteristics that separate the family Canidae from the three other canoid families—the bears, weasels and raccoons — are: good stereoscopic vision, a keen sense of smell, the ability to hear a wide range of frequencies, and long limbs and digitgrade feet that enable them to run fast and cover great distances. In addition, canids are highly

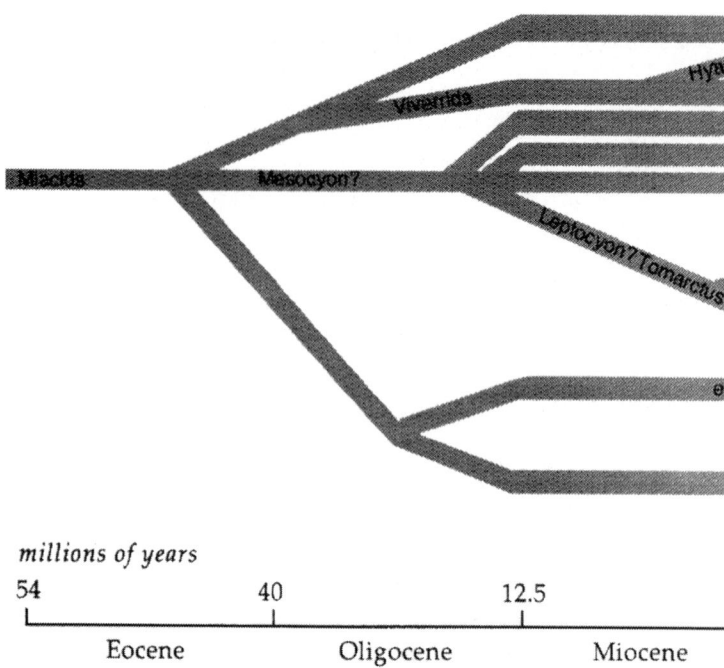

1.1 Proposed family tree of the canids.

intelligent, social animals that take advantage of living in packs to rear their young and to hunt.[4]

Taxonomists recognize a complex series of traits that strictly define modern canids: 1) specialized leg morphology, 2) reduced number of hind toes, 3) advanced body cooling system, 4) keen sense of smell, 5) specialized teeth, and 6) high intelligence. The first three characteristics are derived directly from the canid running (cursorial) way of life, and together they allow for an endurance unmatched in other mammals. The structure of the canid leg, in which certain bony elements produce strong muscle attachments, allows canids to gallop tirelessly after their prey. Alone among carnivores, canids have a reduced number of hind toes (four); the African hunting dog carries this specialization further having only four toes on the fore leg as well. In addition, the advanced body-cooling system of canids enables them to keep going without danger of overheating on even the hottest days. Like the human body, cooling in canids is based on the evaporation of water from moist body surfaces that are richly supplied with blood vessels. In humans, cooling is largely accomplished by sweating and the consequent evaporation of moisture from the skin; in canids the same evaporative process is accomplished by the surfaces of the respiratory

I: THE EVOLUTION OF THE MODERN DOG

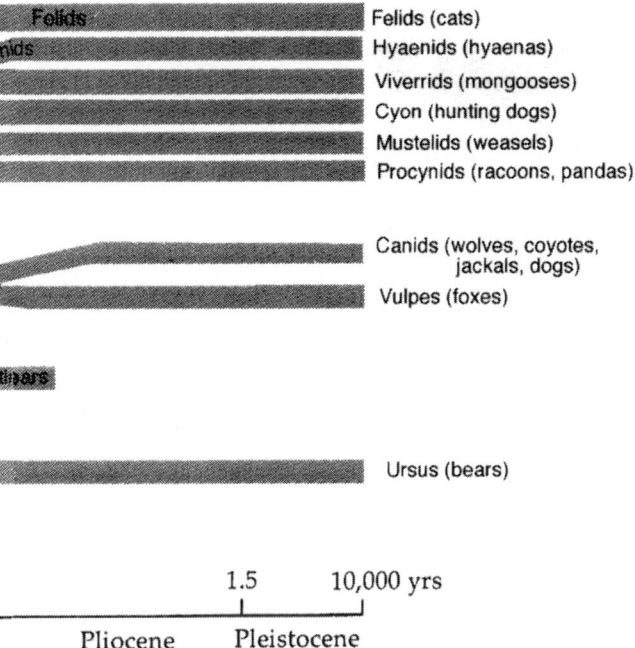

system through panting. Canid panting is not connected with respiration (oxygenation of blood); rather, it is a specialized activity in which the breathing rate increases in response to body temperature. In other words, a cool but galloping dog breathes harder in order to oxygenate its blood, while a warm, resting dog pants in order to cool its blood by passing it around and through the respiratory system at a rapid rate.[5]

Unlike humans and other higher primates, canids rely to a great extent on their noses to locate prey and communicate with one another. Canids possess a superb sense of smell: their long noses contain approximately 15 times the sensory area of that of human beings. They also have a pair of small openings in the roof of their mouths, known as Jacobsen's organs, which they use to 'taste' the air as it is inhaled.[6] The canid sense of smell is so acute that some dogs can differentiate between the scents of identical twins and can even detect the scent of a human fingerprint six weeks after it was laid.

Supplementing the canid sense of smell is a series of glands distributed about the body for the production of odours (pheromones) used in social interaction. Between the pads of the feet, glandular pockets set scents to trails so that one canid or social group may easily follow another within hours or even days after

I: THE EVOLUTION OF THE MODERN DOG

1.2 Reconstruction of a Miacid.

1.3 Reconstruction of a Mesocyon.

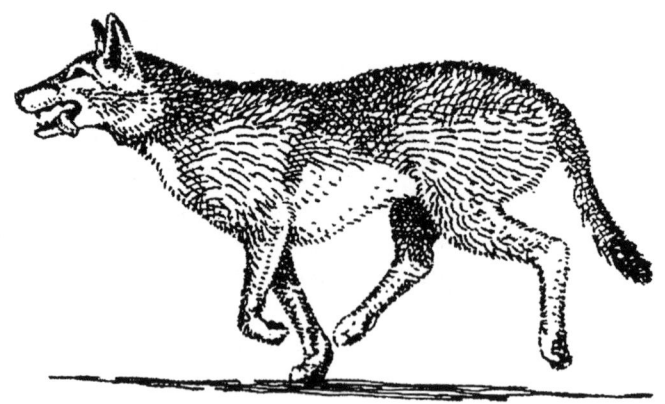

1.4 Reconstruction of a Tomarctus

the first passed by. At the top of the base of the tail, the supracaudal gland offers information on the sexual status of a canid, while other glands alongside the anus mark a canid's faeces for the 'reading' convenience of others. Canid urine also contains a wealth of information decipherable by the acute noses of other dogs, including an individual's identity, age, sex, and mood. Thus all canids mark the boundaries of their preferred paths and indeed all of their wandering by the use of urine on conspicuous landmarks.[7]

Canids are intelligent, social animals. One aspect of this intelligence is that canids instruct their offspring about social living. Canids survive through strategy, which must be imparted to succeeding generations. Strategies in the past were primarily geared toward hunting, survival in the natural world, and avoidance of humans — the dominant terrestrial predator. Yet as the world became increasingly dominated by humans, some canids — the modern dog's ancestors — shifted their educational strategies from lessons geared to avoid humans to lessons on how to survive within human communities.

Origins of the Domestic Dog

Speculation concerning the genetic antecedents of the domestic dog has been part of the scientific literature for well over a century, yet despite such scrutiny the dog's origin has, until recently, remained obscure. In fact, nearly every extant member of the family Canidae has been considered the dog's wild progenitor at one time or another. Darwin, for example, believed the jackal (*Canis aureus*) was the most likely candidate (fig. 1.7), while others championed the North American coyote (*Canis latrans*) (fig. 1.5), the African hunting dog (*Lycaon pictus*) (fig. 1.6), the dingo (*Canis familiaris dingo*) (fig. 1.8), the dhole (*Cuon alpinus*) (fig. 1.9), or the wolf (*Canis lupus*) (fig. 1.10).[8] It has even been suggested that the dog and the wolf coexisted in the wild prior to the dog's domestication, but this position is not supported palaeontologically.[9]

Traditionally three main approaches have been used in the search for the ancestry of the dog: 1) the comparative approach, which contrasts the morphology of existing wild animals to domestic breeds, 2) the longitudinal approach, which looks at changes in captive wild animals over a period of several generations, and 3) the behavioural approach, which assesses similarities and differences in manner between wild and domestic canids. Recently a fourth approach based on molecular biology has been applied. Separately these four avenues of research have failed to produce conclusive and unchallenged results, but taken together they establish a clear evolutionary relationship between the wolf and the dog.

I: THE EVOLUTION OF THE MODERN DOG

1.5 A coyote.

1.6 An African hunting dog.

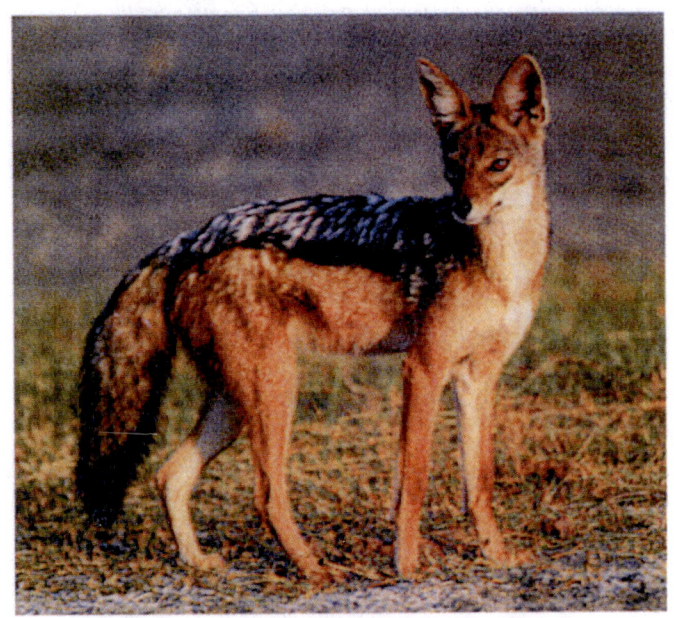

1.7 A black-backed jackal (Canis mesomelas).

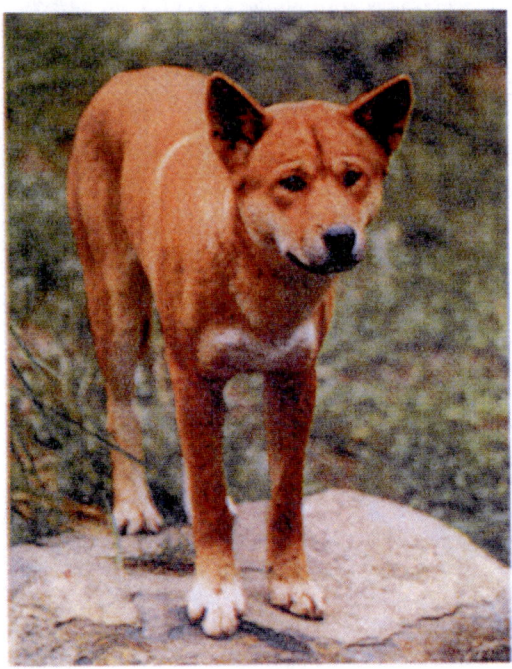

1.8 A dingo.

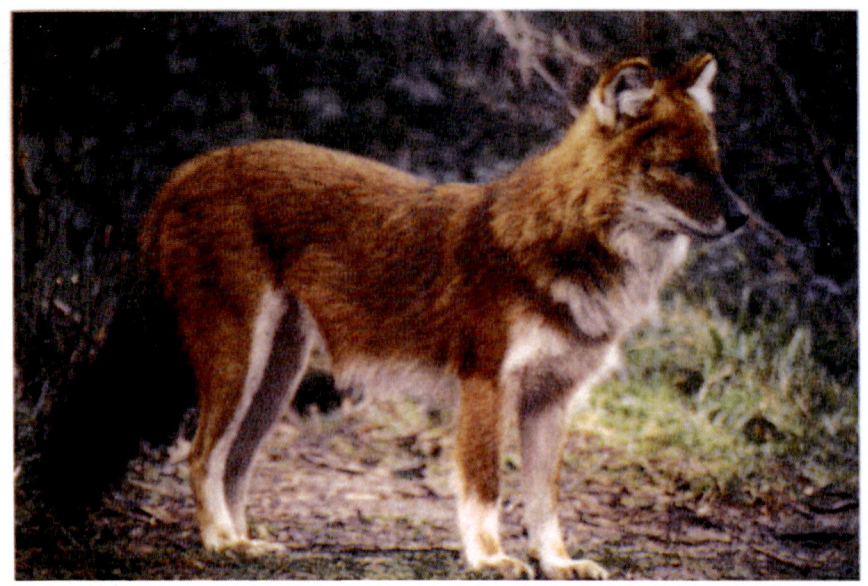

1.9 A dhole.

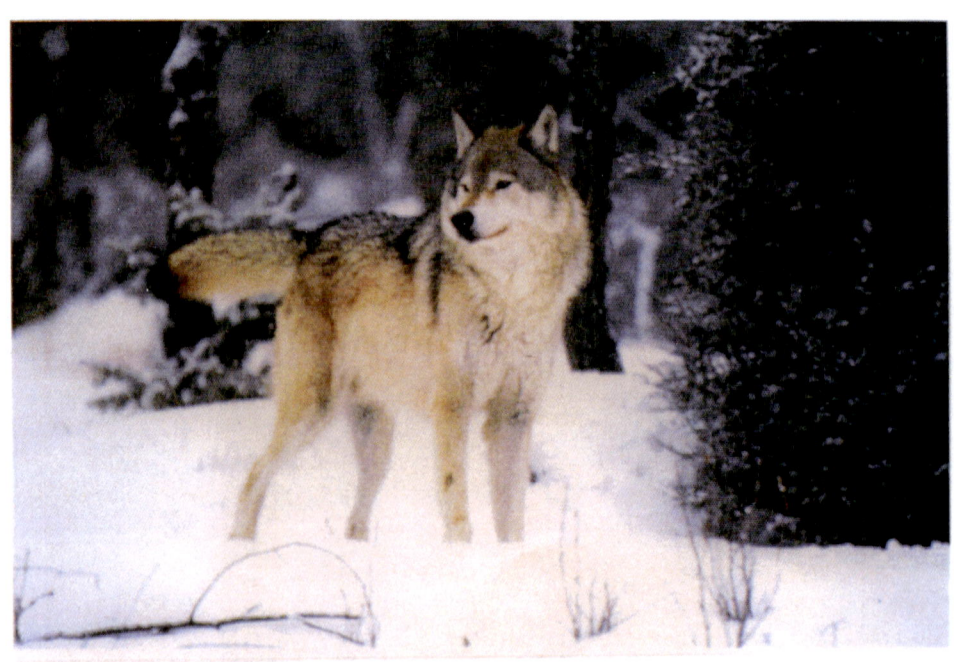

1.10 An American Grey wolf.

Comparative Morphology

The most common approach to elucidating the ancestry of dogs has been through their skeletal anatomy. The underlying assumption of this approach is that the greater the morphological similarity between species, the closer the ancestral relationship. Unfortunately this approach is limited in the case of the Canidae by the homogeneous nature of traits across canid species. For instance, all free-breeding members of the family Canidae are large chested, slim-waisted and long-legged. Some canid lines, however, do possess unique morphological characteristics and can be separated from the other members of the family, thus providing a few clues to the dog's phylogeny. African hunting dogs (*Lycaon pictus*) for instance, have only four toes on their front limbs, while all other members of the genus *Canis* have five. African hunting-dogs also have a clavicle (collar bone) which essentially no longer exists in domestic dogs or wolves. These characteristics eliminate the African hunting dog as a close relative and likely progenitor of the dog. Likewise, the dhole (*Cuon alpinus*) of the Indian subcontinent can be separated from the dog and other members of the genus *Canis* by dentition: The dhole has two lower molars whereas the dog and its close relatives have three. Furthermore, the dhole, like the African hunting-dog, has teeth that are more specialized for meat eating and which resemble the teeth of several groups of extinct canids more than the teeth of the relatively omnivorous dog, jackal, and wolf. These anatomical characteristics, along with subtle distinctions like the larger number of teats in the dhole, places it, like the African hunting-dog, at a greater ancestral distance from the domestic dog compared to wolves, jackals, and coyotes.

Problems with the morphological approach arise when working with closely related species such as the wolf, coyote, jackal, and dingo. The dingo, for example, by all forms of morphological comparison is closest to the dog. In fact, a battery of recent studies have demonstrated that it is nearly identical to the dog. Thus, separating the dingo from the ancestral line of the dog would be impossible based on morphology alone. Palaeontological and archaeological evidence, however, have shown that the dingo did not exist in art or in geological/ archaeological provenance earlier than 6000 BC, which suggests that the dingo was introduced to Australia as a domestic dog by migrating hunter-gathering humans and then subsequently turned feral. On the basis of archaeological as well as morphological, behavioural, and new genetic evidence, the scientific community now believes the dingo is descended from the dog and refers to it as a subspecies of the domestic dog, *Canis familiaris dingo*.[10]

Unfortunately, establishing the relationship between wolf, jackal, coyote, and dog has proven to be more difficult than that of the dhole, African hunting-dog, or dingo. Criteria used to separate these taxa are based primarily on skull shape, body size, the robustness of muscle attachments, dentition, and aperture size of

dentary root sockets. Although these characteristics are qualitative measures that vary from animal to animal and from area to area, they do offer a relative means to assess potential ancestry among several extant canid lines. For example, a significant difference exists between the skulls of jackals and coyotes (which tend to have strongly convex profiles) and the skulls of dogs and wolves (which have concave profiles, i.e, a forehead).[11]

Size also plays an important role in assessing potential ancestry. Changes in body size from a larger wild species to a smaller domestic form is a common response to the domestication process.[12] This observed reduction in body size has been shown in many domestic species to be correlated with changing reproductive strategies. Tchernov and Horwitz[13] suggest that reduction in body size in early domestication reflects a shift from selection for individual variability toward the higher reproductive rates needed to expand into a new niche. Their hypothesis that domestication has affected the development rates of certain biological characteristics in dogs seems reasonable, given that most domestic dogs become sexually mature earlier than wolves and other wild canids.[14]

Because reduction in size is common during the initial phases of domestication, the number of early breeds of large dogs narrows the search of potential

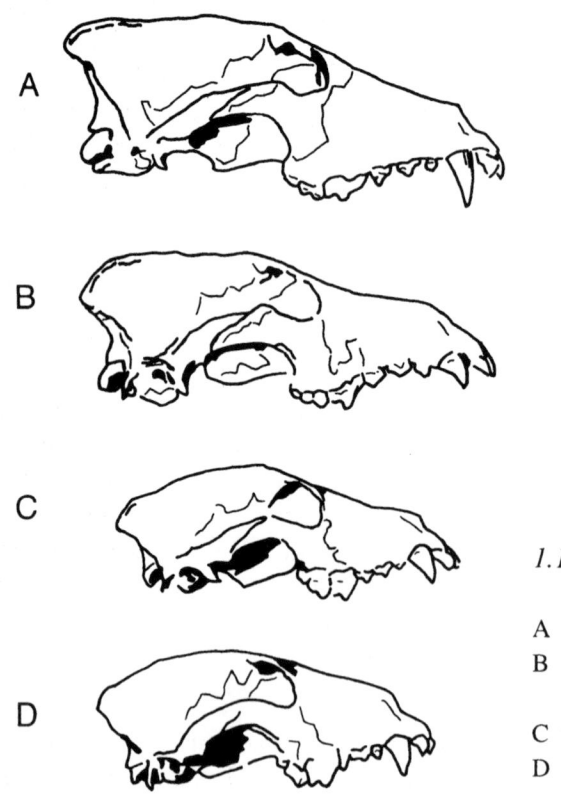

1.11 Wolf skulls

A wild wolf
B wolf captured as a pup and raised in captivity
C wolf born in captivity
D second generation captive wolf

progenitors to the largest wild canid. The jackal (*Canis aureus*), for example, is smaller in overall size and has a smaller skull than many early dogs, thus reducing its likelihood as a possible ancestor. Another interesting point that morphological studies have shown is that domestic animals have proportionally smaller brains than their wild counterparts. This phenomenon is consistent between wolf and dog, but does not hold true between jackal and dog as the jackal has a smaller brain than the dog in proportion to its body size.

Longitudinal Studies

To augment clues obtained through comparative morphology, longitudinal studies have been conducted to elucidate the rate of adaptive change in certain species over several generations. These studies have shown that morphological changes can occur rapidly in captive canids. For example, wolves raised in captivity begin to look like large domestic dogs within as little as four generations. Wolfgram[15] noted significant differences between the crania of wild wolves and wolves born and raised in captivity. Figure 1.11 illustrates the changes that occurred in Wolfgram's study group. Here four skulls are presented: a) a wild wolf, b) a wild wolf captured as a pup and raised in captivity, c) a wolf born in captivity, and d) a wolf born of parents that were born and raised in captivity. The differences in the skulls are striking. The wild wolf and the cub raised in captivity differ mostly in size and robustness of the skull, which is probably a reflection of lifestyle and diet. Significant differences in skull shape can be seen, however, in the wolf that was born in captivity: the cranium is more vaulted, the teeth show crowding, and the sagittal crest is markedly smaller. The second generation wolf skull appears to look like that of a large dog. Its teeth are not only crowded but, in fact, are overcrowded and turned, the skull is vaulted and the sagittal crest much reduced. These changes, which occurred by the second generation of captivity, illustrate how quickly the domestic dog could have developed and also how rapidly different forms (breeds) of dog could evolve.[16]

The crowding of teeth seen in the jaws of Wolfgram's study group has also been observed in many species that have recently undergone size reduction during domestication, because teeth do not reduce in size at the same rate as the skeleton. That many early dogs possessed large, over-crowded, wolf-like teeth suggests evolution from a larger progenitor. The most likely candidate, based on size, is the wolf. Interestingly, this delay in size tooth size response can also be seen in reverse in long established breeds in which dog size has actually surpassed the stature of the wolf. In the St Bernard and Irish Wolfhound, for example, the teeth remain relatively small compared to the skull.

Recent studies using a different application of the comparative and longitudinal approach have produced interesting results. In an attempt to determine if the

morphological differences between the dog and other wild canids could be accounted for by the processes of domestication, two studies have been conducted in which skull measurements from modern wild canids were statistically compared to modern and prehistoric domestic dogs from North America and Europe. Wayne and Morey measured several hundred crania from modern wild canids (*C. lupus, C. rufus, C. latrans, C. aureus*) and compared them to the skulls of modern and prehistoric dogs of both large and small breeds. Their analyses revealed that what set dogs apart from wild canids was the width of their palates and height of their cranial vault. These morphological ratios were unique among the canids and did not conform to allometric patterns among any wild canids. Statistical analyses (bivariate and multivariate) suggested, however, that domestic dog skulls were more similar morphologically to juvenile wolves than to any other wild canid.[17]

The cranial similarity of dogs to juvenile wolves led scholars to further examine morphological relationships between dog and the maturing wolf. In a comparison of snout to palette width, adult dogs were distinct from adult wolves but closely resembled juvenile wolves. Simply put, the criteria used by researchers to identify early dogs (that is, a vaulted cranium, crowded teeth, shortened jaw, reduced musculature) compares more closely to young wolves than to any other wild canid.[18]

These findings raise the question of how the retention of juvenile characteristics into adulthood (paeodogenesis) would serve the early domestic dog. To answer this one must turn to the third main line of evidence: behavioural studies.

Canid Behaviour

Canids are divided into three general types or classes based on their degree of sociability: solitary (e.g., foxes), mated pairs (e.g., coyotes and jackals), and social (e.g., wolves, African hunting dogs, and dholes in which groups usually consist of 7-10 individuals but can sometimes include as many as 60 individuals).[19]

These differing degrees of sociability place different selective pressures on modes of communication: Solitary canids tend to rely less on visual and more on vocal and olfactory communication while social canids have developed a variety of graded visual signals. The fox, a relatively solitary canid, has a simple repertoire of visual signals comprised of facial expressions, tail and body positions. The threat gape of a fox, for example, is very much an all or nothing signal. More social canids, such as the wolf and dog, will use similar types of signals but they are more varied and subtly graded in intensity. Unlike the fox, wolves and dogs can successfully alter signals of submission and defensive aggression or can combine signals of submission and greeting.

These generalizations suggest that increasing sociability and sustained proximity require the development of more sophisticated visual signals. The highly social African hunting dog is the one exception to this generalization as visual signals, especially facial expressions, are notably lacking in complexity in this species. Instead, the core of the African hunting dog's social organization is a ritualised greeting ceremony based upon infantile begging behaviour, which serves to reinforce group harmony by the solicitation and regurgitation of food.

Using behaviour to assess possible progenitors of the dog, two characteristics emerge as important. The dog's ancestor had to be social and its communicative ability had to be compatible with human systems. Using these criteria, the dhole and the African hunting dog can be ruled out immediately — the dhole because it displays a limited repertoire of sounds and lacks olfactory scent marking behaviour, and the African hunting dog because its solicitation and subsequent regurgitation of food offerings limits its adaptability to human society. The coyote and jackal remain possible ancestors when considering the criteria of communication, but they prefer to live in mated pairs rather than larger groups such as early human communities. Likewise the fox, whose communication system of both visual and vocal signals is ostensibly compatible with humans, prefers a solitary existence. The wolf, therefore, with its group oriented social system and highly developed visual and vocal communication system is the only canid that meets both criteria.

But just how do dogs and wolves compare behaviourally? Socially, they both live in groups. In terms of communication, dogs have a less elaborate repertoire of visual signals than the adult wolf but a greater reliance on vocal signals.

There are two main reasons why dogs, although more communicative than most canids, might not use the full repetoire of wolf visual signals. First, it can be argued that the complexities of wolf social behaviour and associated body language are a learned series of expressions that cannot be taught outside of the wolf pack. Thus, a wolf living in a human environment would have fewer opportunities to learn wolf body language. It would thus retain the vocalizing means of communication used by young wolves that had yet to adopt the visual forms of communication. Second, a wolf reared in human society would have to learn to communicate in a manner understood by humans. Because humans rely on vocal communication much more than physical signals, vocalizing would serve better than visual signals. Humans could misinterpret or more likely not even notice a subtle visual cue but vocalizing would certainly get attention. Thus by retaining the vocal communication traits of the juvenile wolf, the early dog would have a readily understood mechanism for communication.

Scholars studying the behaviour of both wild and domestic canids have concluded that adult dogs most closely resemble juvenile wolves, a finding that

mirrors those of morphological studies.[20] The retention of juvenile behavioural characteristics (neotony), such as play soliciting, care soliciting, and submissiveness may be a conditioned response that replaced adult wolf expressions. Because the human environment has different selective pressures, canid socialization and other behaviours changed to fit into the new human niche. As in morphological changes, the ability to adapt behaviourally to new situations would be a driving force, and the retention of juvenile behaviour with its inherit plasticity was the adaptive response. Simply stated, juvenile behaviour is easier to modify than that of an established adult. Also, the behaviour of the juvenile wolf, with a repertoire of social skills and communication signals yet to be learned lies, like the dog, somewhere between the socialized adult wolf and the less social canids, like the coyote.

Genetic Evidence

Molecular and genetic studies are the newest means of investigating the dog's origin. Studies on canid blood, blood proteins, and enzymes were among the earliest attempts to assess genetic affiliations at the cellular or molecular level. Simonson conducted an extensive investigation of canid blood protein and enzymes.[21] Dogs, like humans, possess different blood types and at least six distinct immunoglobulins, which combined with other data help establish genetic relationships between the canids. After conducting numerous tests and cross-tests using different blood proteins and enzymes, it became clear that a number of canids (*Lycaon, Vulpes, C. aureus.*) could be reliably differentiated from the dog, but no statistical differences could be found between the dog (*C. familiarus*), wolf (*C. lupus*), coyote (*C. latrans*) and red wolf (*C. rufus*).

The study of canid chromosome structure and make-up was the next critical step in the study of the dog's origins and taxonomy. Chromosomes are composed of genes that in turn are made up of DNA. All DNA testing works on the principle that the information encoded in genes making up the chromosomes is sexually transferred from parents to offspring, the ancestral sources of DNA can be identified, and that mutations occur randomly at a predictable rate. The working assumption is that the greater the similarity in DNA structures between two tested organisms, the closer their relationship. Conversely, the greater the differences, the further back in time they shared a common ancestor.

Currently there are two methods of assessing ancestry through DNA, one that analyzes nuclear DNA and one that analyzes mitochondrial DNA. The traditional method and the one used in modern crime investigations employs nuclear DNA. Dogs, humans and other animals receive their nuclear DNA from both their parents; when fertilization occurs, DNA from both parents combines to form the new organism's nuclear DNA. At its most robust level, nuclear DNA testing suggests four phylogenetic divisions within the Canidae: 1) the wolf-like canids,

including domestic dogs, grey wolves, coyotes, and jackals, 2) The South American canids, including species of diverse morphology but common recent ancestry such as the small eared dog, maned wolf and bush dog, 3) the red-fox-like canids of the Old and New World, including kit foxes, and 4) monotypic genera such as the bat-eared fox and raccoon dog that have a long, separate evolutionary history. The fossil record and genetic distances indicate that these four divisions began about seven to ten million years ago.[22]

The most promising of the new molecular studies to be applied to the problem of dog origins, however, is mitochondrial DNA (mtDNA) testing. These studies analyse mitchondrial DNA — the genetic code that builds and maintains the mitochondria of the cell — which is received only from the mother. The mitochondria contain enzymes that convert food into energy that the cell needs to survive. They are located within the cell, but not within the nucleus of the cell and are therefore physically separate from nuclear DNA. In theory, an individual's mtDNA is exactly like that of his or her mother's, and hers is exactly like that of her mother, and so on through the generations. Over time, however, mutations occur which provide different mtDNA structures that are passed down the lineage. As in nuclear DNA testing, the more generations that have passed, the greater the number of mutations there will be in the code. Thus, when two species are tested, the greater the difference in their mtDNA code, the further back in history their common ancestor lies. Conversely, stronger mtDNA similarly infers a closer relationship or more recent ancestry.

Mitochondrial DNA has been used to further investigate the phylogenetic relationship of the wolf-like canids of which the dog is a member. Such analyses have revealed a close relationship between grey wolves, dogs, coyotes, and Simien jackals. As a group these four taxa are distinct from the African hunting dog and from the golden and black-backed jackals. The grey wolf and coyote are genetically very similar and probably had a common North American ancestor as recently as two million years ago. Interestingly the Simien jackal, an endangered species found only in a small area of the Ethiopian highlands, is genetically more wolf-like than jackal-like and probably should be referred to as a wolf.[23,24]

Further testing included a limited mtDNA restriction fragment analysis of seven dog breeds and 26 grey wolf populations from different locations around the world. These tests have shown that the mtDNA genotypes of dogs and wolves are either identical or differ by the loss or gain of only one or two restriction sites. In other words, the domestic dog is an extremely close relative of the grey wolf, differing from it by *at most* 0.2% of the mtDNA sequence — a figure smaller than the difference between many human ethnic groups.[25] These results underscore the close relationship between dog and wolf. In comparison the wolf differs from its closest wild relative, the coyote, by about 4% of the mtDNA sequence.

In summary, on the basis of morphological and behavioural evidence the dog is more similar to the juvenile wolf that to any other species. At the molecular level, dogs are wolves, and the wide variation in their adult morphology probably results from simple changes in developmental rates and timing.[26] It is one thing, however, to note that dogs are closer to wolves than any other animal, but quite another to prove it unequivocally. Like all assessments of ancient ancestry, new fossil finds and new technical analyses change our understanding of family trees. The human fossil record is a case in point: new fossil finds reconfigure our ancestral tree almost on an annual basis. In reality the assessment that the wolf is the progenitor of the dog is a working hypothesis that currently is supported by several lines of independent evidence (behaviour, morphology, genetics). The parallel conclusions of these investigations strongly suggest, given current knowledge and understanding of evolutionary processes, that the wolf is the domestic dog's most recent ancestor.

Notes

1. Mathew 117-138.
2. Tedford 74-83 Mathew 117-138, McLoughlin.
3. Nowak and Paradiso.
4. Savage and Long 76.
5. Novak & Paradiso, McLoughlin.
6. McLoughlin.
7. McLoughlin.
8. Galton 122-139, Darwin, Allen 431-517, Dahr 1-56, Werth 213-60, Scott 1968, 243-75.
9. Fox 1978a.
10. Macintosh 187-106.
11. The Simien jackal has a concave profile and thus is an exception to this trend.
12. Jarman & Wilkinson 83-96.
13. Tchernov & Horwitz 54-75.
14. Scott & Fuller, Fox 1978, 19-30.
15. Wolfgram 773-882.
16. Wolfgram 733-882.
17. Wayne 1986a, 243-61, Wayne 1986b, 301-19, Morey 1990, see also Morey 1992, 181-204, Morey 1994.
18. Morey 1990.
19. Hall & Sharp. See also Fox 1975, 429-60.
20. Fox 1978, 19-30, Schotté & Ginsberg, 349-74.
21. Chiarelli 40-53, Simonson, 7-18.
22. Wayne 1993, 218-24, see also Chiarelli 40-53, Seal 27-39.
23. Wayne 1993, 218-24.
24. DNA analysis is not without problems. An unexpected result of genetic research was the high divergence that was found between two black-backed jackals in the same population. This was the largest divergence in mtDNA ca. 8% recorded within a freely interbreeding single population. Such divergence underscores the need for caution in interpreting phylogenies based on mtDNA alone, as the resulting gene trees may not always accurately reflect phylogenetic relationships (Wayne 1993, 218-43).
25. Wayne 1993, 218-42, Serpell 1995, 33.
26. Wayne 1993 218-42.

CHAPTER TWO
The Path to Domestication
Douglas J. Brewer

If the molecular, behavioural and morphological studies are indeed valid, and the wolf is the ancestor of all dogs, how did the wolf become domesticated and how did it evolve into so many domestic forms? The answer to this question may lie in the current definition of species, our vernacular terminology and perceptions of what constitutes a wolf, and in the genetic plasticity of the wolf. The latter bears directly on the wolf's adaptability to different environments and ultimately to its overall morphology.

First, the concept of species that has been adopted by many biologists actually possesses two philosophical extremes. One side views species as clusters of organisms possessing uniquely shared traits. Opponents believe that species are genetically separated groups that are unable to interbreed. Adherence to the former definition leads to separate species designations for dogs, wolves, coyotes, and the rest; but by strictly adhering to the latter definition, dogs, wolves, and coyotes are really a single species because they interbreed and produce not only viable hybrid offspring but breeding populations of offspring such as the red wolf (which is a cross between a wolf and a coyote).

Second, by stating that the dog is a descendant of the wolf, Europeans and North Americans automatically picture the large northern wolf as the ancestral form and exclude other more gracile forms. Wolves are very adaptable and a number of different geographical 'races,' or subspecies, encompassing all sizes can (or could) be found throughout the world, for example the Arabian wolf (fig. 4.1). It is probable that the larger northern varieties as well as the smaller southern forms all contributed to the genetic pool of the modern dog. There is no reason why different breeds of dog could not have evolved from different geographical 'races' of wolf. Thus, dogs could have differed significantly in size and colour very early in their developmental history. Assuming a degree of adaptability similar to their immediate ancestors — the wolves — early dog populations likely underwent further morphological changes induced by human selection quite rapidly.

If the wolf is indeed the ancestor of the dog, the most reasonable scenario for the origins of canid domestication is as follows. For many years, human hunter-gatherers and wolves existed in overlapping niches and were accustomed to contact with each other: both were social species that hunted for many of the same prey items. As opportunistic scavengers, wolves may have learned to follow human hunters and to scavenge from human kills, and humans probably learned to do the same with wolves. Over time some wolves became peripheral

residents of the human community. These animals were not integrated members of a human group but rather were common visitors to the outskirts of the community and were tolerated by the human inhabitants. Finally, and most likely in more than one time and place, some of these visitors were adopted into the human community, probably as pups. Since it is common in all human cultures to adopt abandoned/orphaned young of other species, the human 'mothering' instinct is apparently a very basic one and must date to early in our development as a species. Hence, it seems most credible that early humans would commonly adopt wolf pups in similar situations. Numerous studies have shown that wolf pups taken at an early age and reared by humans are easily tamed and socialized. According to Scott and Fuller the most crucial social bonds of a dog's or wolf's life are formed when the animal is three to eight weeks old.[1] Wolf pups adopted and socialized by humans during this period form their primary social bonds with members of their 'human pack.' Although adult animals can be socialized, it is much more difficult with advancing age.[2]

In terms of evolutionary success, an adopted wolf's options for contributing offspring to future generations were limited by human culture. Individuals whose temperament prohibited their successful integration into human society would likely have been destroyed. Therefore, for an adopted wolf to contribute to future generations it had to fit into human society and remain there. With that, the domestic relationship that produced dogs from wolves had begun.[3]

The early adopted canids were essentially tame wolves, but wolves that grew up quite differently from their wild counterparts. Humans, the source of their food, are omnivorous, and human hunter-gatherers likely provided their young wolves with a similar diet. Some scholars believe that because young wolves brought into captivity were forced to survive on different foods, they experienced nutritional stress during their early months and this resulted in a reduction in stature.[4] Although nutritional stress could account for the decrease in size of early domestic dogs, this hypothesis does not correlate well with other data. Instead, because dogs spread and diversified so rapidly across the entire world, it would seem that the new niches they were exploiting were rich in food resources. Other biological studies have shown that when a species enters a new unexploited niche, its rapid spread is facilitated by reaching sexual maturity sooner.[5] When this occurs, the energy usually devoted to growth is channelled into reproduction, leaving the animal smaller in stature. In a sense, the price paid by a species for rapidly expanding in to a new niche is a reduction in size. This scenario seems to fit the wolf/dog situation better than the lack of food hypothesis.

Although the precise means of the dog's introduction into human society remain unproven, it is easy to see how dogs' keen sense of smell, territoriality and innate hunting abilities might offer a selective advantage to those human groups that included them within their society. But dogs might well have been domesticated

for different reasons in different parts of the world. Another important reason for adoption could have been as a source of food. All domestic animals, with the exception of the cat, entered the cultural environment as a food source. Horses, cattle, pigs, sheep, goats and dog are all herd or pack animals, and all are known food items in extant cultures.[6] It seems most likely then that in each geographic area where canids were adopted, different circumstances dictated different roles for the dog, and different physical types developed.

As humans expanded across the landscape, a variety of dog forms spread with them. Subsequent population expansions occurred when humans created new environments with the agricultural and urban revolutions. The move to village life and agricultural-based economies brought new niches for dogs to fill, such as guard dog and shepherd. Urbanization and state level society also brought with it new needs: dogs for policing, dogs for war, and simple lap dogs for people in confined urban spaces.

The Earliest Domestic Dogs

Canid remains believed to be examples of the earliest domestic dogs have been reported from several parts of the world, but the most ancient examples come from southwest Asia and the Levant.[7] The extremely early dates (pre-7,000 B.C.) assigned to these specimens, however, cannot be unequivocally substantiated. For example, a partial mandible from Palegawra Cave in Iraq is often cited as the earliest domestic dog.[8] Although the specimen possessed closely spaced teeth, it was found in association with deposits that dated to c. 10,000 B.C., and was smaller in size than the modern wolves of the region, the fact that it was an isolated find with no domestic dog-like remains in closely associated stratigraphic levels and was in some respects wolf-like suggests to some critics that the jaw simply represents an atypical wolf.[9]

A second very early domestic dog has been reported from Israel. Scholars compared the length of two lower first molars recovered from Natufian contexts (c. 10,000-9,000 B.C.) to corresponding lengths from a variety of modern wolves. The Natufian specimens were small compared to the wolves used in the study, and therefore were classified as domestic dogs.[10] The specimens, however, did fall within the lower size range of the small Arabian peninsular wolf. Furthermore, during the late Pleistocene there was a general trend toward size reduction in wild canids, making it even more problematic to separate wild from domestic forms based on size alone. Thus, the identification of the Natufian specimens as domestic dogs needs to be considered, like the Iraqi finds, with caution.

Beyond the Mediterranean region a fragmented cranium from Starr Carr, England (c. 7,500 B.C.) remains one of the oldest examples of an early domestic dog from Europe. Critics have suggested the find is that of a tame wolf pup, but even if

this is so, the animal must have been under human care and must surely represent a canid adjusting to a new 'lifestyle'. Other more tentative claims for early domestic dog remains include those recovered from Senckenberg (8,000-7,000 B.C.), Bonn-Oberkassel (12,000 B.C.) in Germany, and Döbritz-Kniegrotte in the Czech Republic (pre-7,000 B.C.). Unfortunately, these remains do not stand up to the same level of scrutiny as the Star Carr find. Scholars working with the Czech specimens, for example, were deliberately tentative in their taxonomic assignment. The Bonn-Oberkassel specimen, a mandible that lacked teeth, was excavated nearly 80 years ago and seems to be an aberrant individual with unerupted teeth. The Senckenberg specimen, although a complete skull and certainly a dog, remains questionable due to insecure dating.[11]

The oldest domestic dog material reported from the New World comes from Danger Cave, Utah, where researchers have suggested that a mandible and several small skull fragments were derived from a dog living about 8,000-7,000 B.C..[12] Published photographs and measurements tend to support the claim. The report of a dog in excess of 8,000 years old from Jaguar Cave, Idaho, has been determined to be no more than 2,000-3,000 years old.[13,14]

It should be stressed that the various claims for the earliest domestic dogs, although contested, are not examples of poor science. The identifications were made by competent scholars, using the evidence they had available to them. Even to the uninitiated it must seem clear that fragments of mandibles and isolated teeth thousands of years old do not lend themselves to easy identification. Furthermore, problems can arise when attempting to assign fossil remains to less inclusive taxonomic levels such as genus and species. In fact, this is one of the inherent problems in attempting to identify the earliest example of a species: there simply are not enough fossil samples nor are these well enough preserved for unambiguous taxonomic identifications. In other words, so few specimens exist and for the most part they are so poorly preserved that an indisputable identification beyond the level of family (i.e., Canidae) is all but impossible.

In sum, although a number of finds look promising, none dating earlier than 7000 B.C. are unquestionably. After 7000 B.C., however, a number of examples exist, and the frequency of finds increases through time.

It is perhaps noteworthy that about 7000 B.C. agriculture was spreading rapidly throughout the world as an alternative to hunting-gathering (which had been the sole means of human subsistence before 9000 B.C.). It has been argued that the nearly simultaneous adoption of agricultural economies throughout the world could only be accounted for by assuming that hunting and gathering populations had saturated the world by approximately 9000 B.C. and had exhausted all possible strategies for increasing their food supply within the constraints of the

hunting-gathering lifestyle. The only possible reaction to further growth in population worldwide was to begin artificial augmentation of the food supply. Within such a scenario, it is possible that the dog, which may have evolved to fill a variety of roles in the late pre-agricultural period (Late Paleolithic) was poised to expand into the new socio-agricultural niche just as it was being adopted by humankind.

The dog was, as we have seen, already domesticated before the agricultural revolution. Clearly the introduction of the dog into Australia and North America by hunter-gatherer peoples demonstrates the dog's close and widespread association with humans during the late Paleolithic. The Neolithic shift to food production and a more sedentary human lifestyle, however, offered additional niches for the dog to fill. A settled life brings with it stronger cultural notions of territoriality, in terms of both space and non-portable possessions. Under these circumstances the dog could serve a number of additional functions from guard animal to refuse cleaner or hunter or even being a food supply itself. Villages, towns and cities changed through time offering the dog countless new avenues for adaptation, ultimately leading to the development of a multitude of different breeds throughout the world. In fact, the canid's genetic and behavioural plasticity makes it perfect suited to sedentary agricultural life.

The Earliest Breeds

Scientific opinion varies widely regarding when dog breeds and breeding began. Much of the debate centres on how a breed is defined: is it purely a cultural phenomenon or is it a biological issue? For example, some scholars believe that unless there is evidence that certain animals were held for stud, inferior pups culled, certain animals intentionally crossed, pedigree records maintained, and maintenance of the breed guided by established standards, a true breed does not exist. Adhering to such a definition implies that breeds are intentionally derived cultural phenomena and have existed only in the literate and very recent past. Jasper Rine, director of the dog genome project, disagrees with such a narrow definition.[15] In his study, which seeks the genetic roots of complex physical traits, diseases and, behaviours in dogs, he states that "dog breeding is a well-established art, but a crude, unestablished science ... breeders mate two dogs who look good and see what comes out. There is not enough understanding of chromosomes to track the things that they are interested in ...". Thus, by Rine's definition, the art of mating two dogs with desirable characteristics in order to produce a similar next generation – a practice that was certainly known to early cultures like those of Egypt and Mesopotamia – is the fundamental basis of establishing a breed and was likely practiced very early in the dog's history.

Biologically, breeds are groups of individuals of a species that strongly resemble each other based on a series of characteristics. These characteristics are regarded

as typical within the group, but are identifiably different from other individuals of the same species. A breed is thus similar to a biological subspecies, but with a crucial distinction. Breeds owe some if not all of their identifying characteristics to human selection, regardless of whether that selection was intentional or not, while subspecies result from natural selection within a limited geographic area.

The development of early breeds was furthered by the dog's relative isolation and restricted mating opportunities: first, local wolves willing to maintain a subservient role to human and to live within ecological and cultural boundaries set by human groups were a small subset of the original wolf population. Second, early tamed wolves living with prehistoric cultural groups were maintained in small numbers with limited (in relation to wild populations) opportunities to interbreed with dogs (or wolves) in other groups. Third, the pool of wolf genes within a given cultural group or area represented only a small part of the entire original gene pool of wolves and their appearance and behaviour depended on the individual animals that were initially adopted (i.e. the initial colonizers). Offspring in succeeding generations, because their genetic make-up was limited to that small group of initially tamed wolves, followed a slightly different evolutionary course and 'looked or behaved' differently than the original and more diverse wild population.

As geneticists have pointed out, diversification of form ensues when a population is divided into small subpopulations where limited contacts permit only occasional gene exchanges between them. The dog, originating from a locally adapted wolf population, then divided among different hunter-gatherer peoples and later different settled agricultural peoples fits this scenario for diversification perfectly and probably led to the foundation of breed differences.[16] Allen noted this very phenomenon when studying populations of Native American dogs.[17]

American Indian tribes had their own breeds of dogs that differed little from their neighbours but looked significantly different from dogs found in groups further away. The same process was also at work in the Mediterranean region, where the large war-dogs of Asia Minor and the sleek sight-hounds of North Africa originated as local variants of a large and spreading dog population. Thus within the array of human societies, ranging from nomadic hunters-gathers to farmers to urbanites, dogs found new and growing habitats to exploit and diversify and that adaptive radiation took place soon after the dog was domesticated giving rise to many early forms.

The dog, it must remembered, is genetically a wolf, and the cultural conditions of the human group selected which physical, mental and behavioural traits dominate its character. Repetition through several generations created a physical-behavioural type or breed. A sheep dog herding sheep, for example, must maintain the 'chase mode' but suppress the wolf's instinct for physical attack. A

sheep dog that continues through to the attack, will ultimately be destroyed and his/her genetic makeup slowly removed from the sheep-dog gene pool. The fact that the 'attack mode' is intentionally removed from the pool provides direction to the future behaviour of the breed. Similar types of decisions also act on morphology. For example, removing large aggressive dogs from the gene pool would lead to smaller more behaviourally compatible animals. Human groups in different areas of the Mediterranean would have selected canine traits for different tasks and over time these would have led to discernable differences in their dogs' appearance. Furthermore, once the connection between mating and desired characteristics in understood, the art of pairing dogs with the hope of an intended outcome provides the rudimentary beginning of modern breeding and husbandry.

Regardless of how the dog entered human society or what specific cultural niche the dog might have filled, if one looks at the problem from purely a survivalists standpoint, associating with humans was the best thing a canid species could do. Species success is based on its reproductive ability, which relates directly to its survivability and spread. By associating with humans, domestic canids (dogs) multiplied dramatically in numbers and spread to every continent in the world. Their diversification in size, shape and development resulted in their eventual dependence on humans for survival. Domestic dogs became a new species when they reached the point genetically at which they could no longer compete successfully in the wild and breeds expanded as the need for dogs to fill additional roles in society grew.

Notes

1. Scott & Fuller, see also Scott 1976, 373-81.
2. Anatomical and behavioural similarities between dogs and juvenile wolves are discussed on pp. 18–20.
3. Morey 1990.
4. See Morey 1990, 27-31.
5. Tchernov & Horwitz, 54-75.
6. Serpell 1989, 10-21, Reed 1969, 361-80, Zuener.
7. Clutton-Brock 1995, 7-20, for a critical review see Olsen.
8. Turnbull & Reed, 81-145.
9. See Olsen.
10. Davis 1978, 610.
11. Olsen, Clutton-Brock 1995, 7-10.
12. Grayson.
13. Lawrence 1967, 44-59.
14. Gowlett et al., 145-6.
15. J. Rine, *New York Times*, 12-3-91.
16. Scott & Fuller, Scott 1968, 243-75, see also Scott 1976, 371-81.
17. Allen, 431-517.

CHAPTER THREE
Ancient Egyptian Dogs
Douglas J. Brewer

Dogs probably entered Egypt via the same eastern path as the early domestic ungulates (sheep, goats, and cattle) and they appear in the archaeological record around the same time. These earliest dogs were probably not hunters but scavengers and watchdogs, since such a role relied on the dog's innate tendency to scavenge and protect its territory and required little or no training. By the time dogs first appear in the artistic/archaeological record, however, they had evolved into superb hunter/trackers.

Pictorially, the earliest representations of the dog come from Neolithic rock art of the Western and Eastern Deserts, in which dogs are shown accompanied by human figures, cattle, giraffes, and antelope (figs 3.6–7). Winkler classified the rock art of the Eastern and Western Deserts into a series of basic styles.[1] The earliest group, the western hunters, depicted dogs that look much like the dogs found today among Berber peoples: they have long bodies, long legs, pointed erect ears, and tails carried high over their back. The latter two characteristics are indicative of the earliest dogs: erect ears are typical of the wolf and other wild canids, and the cocked tail develops in tame young wolves raised in captivity.[2] The rock drawings of the early western hunters are followed by pastoral scenes that depict large dogs similar to those shown in the western hunter's scenes as well as slender, erect-eared dogs. Associated with a third style of rock art, nautical in nature, is another dog form. This variety is a smaller, stockier dog possessing a short neck, short legs, long erect ears, and a straight tail.[3] These early drawings are too crude, however, to be able to determine whether they represent distinct breeds.

The earliest physical evidence for dogs in Egypt comes from the earliest dated Neolithic agricultural communities of Merimde (c. 4,800 BC). Individual dog burials at these and later Predynastic sites suggest that dogs reached some degree of status early in Egyptian history. Dog burials have been recovered from Mostegedda and Badari in Upper Egypt as well as Heliopolis, Maadi, and Wadi Digla in the Delta.[4] Dogs interred with humans are known from Predynastic Nag ed Der, Mahasna, and Abadiyeh.[5]

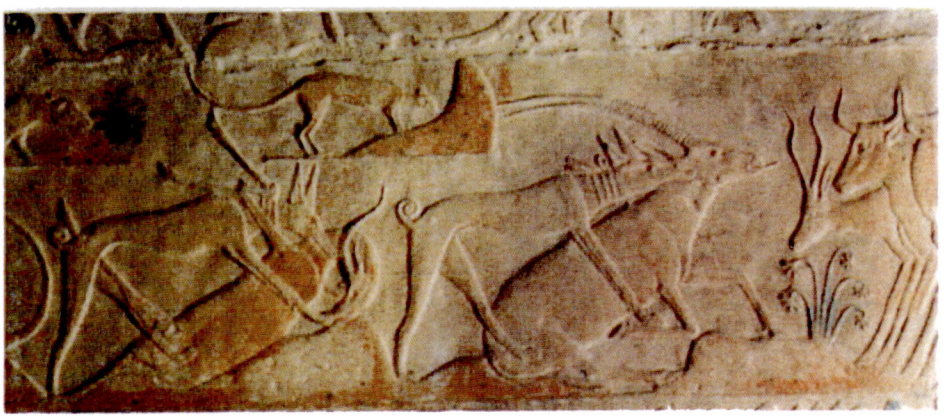

3.1 *An Egyptian sight-hound being led by a servant.*

3.2 *Two Tesems from the tomb of Ptahhotep, Dynasty V.*

III: ANCIENT EGYPTIAN DOGS

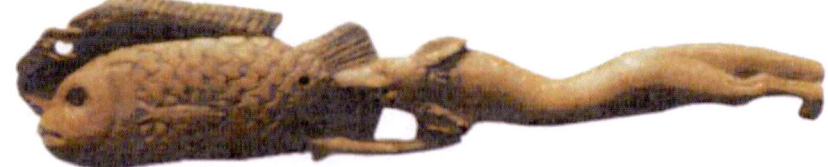

3.3 Cosmetic case, a dog biting a tilapia

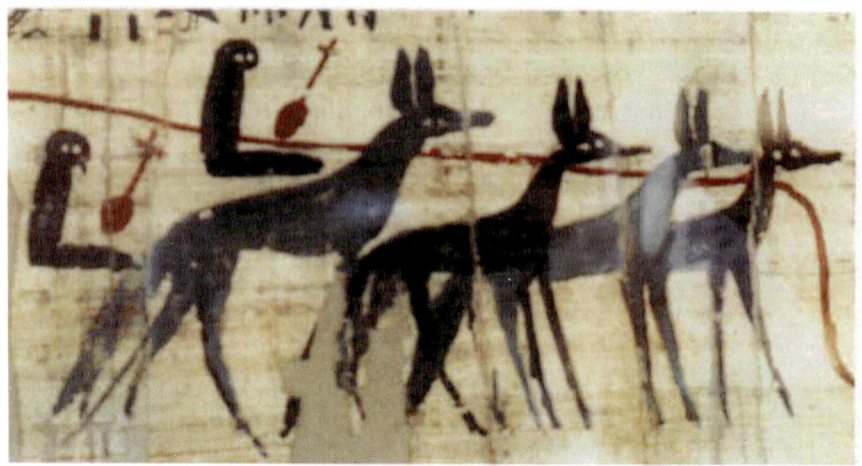

3.4 Anubis from a Papryus.

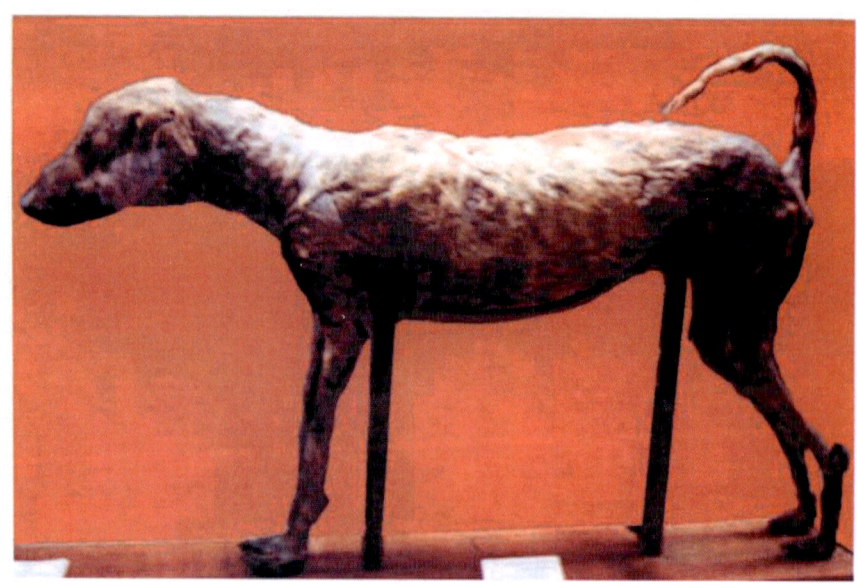

3.5 A mummified dog from Egypt.

III: ANCIENT EGYPTIAN DOGS

3.6 Petroglyph from the Eastern Desert with a hunting dog.

3.7 Petroglyph from the Eastern Desert of a dog with a bowman hunting an ostrich.

Although no textual or archaeological data unequivocally supports the existence of a canine breeding program in Egypt, there is evidence to suggest one existed:

a) ancient Egyptians were clearly aware of the biological implications of sexual intercourse;

b) they strictly adhered to hereditary succession in the royal family and desired to keep the royal blood-line 'pure' through interfamilial marriage, which underscores their belief in the passing of traits from one generation to the next;

c) distinct types of cattle and other animals were known to exist in Egypt from at least the Old Kingdom. These distinct types (the White cattle of Syria, Red cattle of Nubia and others), although perhaps of foreign origin, were certainly recognizable and identifiable subspecies or breeds of animals that were kept and maintained as distinct forms through several generations. This implies knowledge of breeding practices, and, if applied to cattle, it is not hard to accept the fact that dogs were mated to achieve or maintain desired standards as well.

Breeds Based on Artistic Representations

Painted ceramic vessels and scenes in tombs may provide evidence of physical standards for dogs. Whether the depicted animals existed in great numbers or as breeds is not known, but the fact that they were frequently portrayed suggests the existence of an ideal standard for the dog. That the diversity of these standardized forms of dogs increased from Predynastic to New Kingdom times (c. 4,000-1,500 BC) strongly suggests certain physical attributes were selected, and groups of these animals were reproductively isolated to maintain standard types. In other words, the ancient Egyptians were making a conscious effort to create and maintain certain breeds.

Determining breeds from artistic representations, however, can be problematic. Some scholars see many breeds — practically a separate breed for every type pictured — while others see only a few breeds with many varieties. Presented below is a review of the ancient Egyptian breeds commonly recognized by scholars.

Sight-hounds

There are two major types of sight-hounds depicted in Egyptian art. The first is the slender, erect-eared, curly-tailed canine commonly referred to in scholarly and literary works as a tesem (ancient Egyptian *tsm*) (figs 3.1–.2, 3.8). Although *tsm* meant dogs in general and is not a referent to a particular breed or type of dog, because of its usage in the modern literature this nomenclature will be retained here as a referent for this type of sight-hound. Tesems first appear on painted pottery and rock art dated to Naqada I and II times (3750-3400 BC) and are frequently portrayed in Old Kingdom and Middle Kingdom desert hunting

scenes where a sight-hound would have a distinctive advantage over a scent hound. One of the earliest and clearest depictions of this type of dog is on a steatite gaming piece recovered from the first dynasty tomb of Hemaka (fig. 3.8). Here, the hounds are vividly pictured attacking gazelle. Tesems are also pictured on leashes or sitting under the chairs of their masters. Osborn believes that these dogs were bred in Egypt by the early Dynastic period, and based on the number of clear depictions as well as scenes showing puppies, his suggestion seems valid.[6]

3.8 Two Tsm *(Tesem) hunting gazelle on a gaming piece, tomb of Hemaka, Dynasty I.*

Because dogs similar to tesems were known in antiquity to accompany the pastoral peoples of the Eastern and Western Deserts, and erect-eared sight-hounds are shown in rock art of the Atlas countries, the range of this dog is thought to have extended across much of ancient North Africa.[7] Whether the original parent stock from which the Old Kingdom form evolved was indigenous to East Africa or was introduced from western Asia is unknown, although the recovery of skeletal remains of a similar sight-hound from the Ubaid Period in Mesopotamia tends to favour southwest Asia as the source.[8] During Dynastic times, however, there is evidence that tesems were imported into Egypt from the south (modern day Nubia and Somalia).

A second type of sight-hound pictured in Egyptian art has a shorter, heavier muzzle than the tesem, is lop-eared and has a curved or sabre tail. This type of

dog is commonly referred to in the modern literature as a Saluki (figs 3.9–11: cf. figs 4.14–15, 4.17–18).[9] In depictions, their pelage varies from black and tan to cream or white, and sometimes blotched brown or black on white. Saluki-type dogs are sometimes shown with long, feathered hair on their ears, thighs, and tail, characteristics of the modern Saluki breed. Saluki-type dogs appear side by side with tesems in several Middle Kingdom hunting scenes; in New Kingdom art they dominate several hunting scenes and also appear on materials recovered from Tutankhamun's tomb (fig. 3.11). That Saluki-type dogs often appear taller and more gracile than the tesem suggests they are a more refined sight-hound, clearly adapted for speed. The origin of the Saluki-type dog remains obscure, but its inclusion in scenes of Nubian tribute processions suggest that it was bred beyond Egypt's borders.[10]

3.9 A Saluki-type dog, Western Thebes, Dynasty XVIII.

Unfortunately, for those interested in definitive assessments of ancient breeds too many inconsistencies exist in the pictorial record to clearly assign modern breed names to these ancient dogs. Scenes of erect-eared dogs are shown with curled tails and straight tails, lop-eared dogs are shown with sabre tails and curled tails, and erect-eared curly tailed dogs are even shown suckling lop-eared straight tailed pups. This mix of characteristics suggests that the Egyptians themselves may not have used these features to identify their hounds, and that our usage of them is an artificial distinction we have imposed. Whether the lop-eared hound is a descendant of the earlier erect-eared tesem or an introduced species is a matter of conjecture. One could even postulate that the ears of some hounds were clipped, as is done with modern breeds like the German Shepherd, and that this practice was abandoned in later periods. Until molecular tests can be conducted on their remains, the identification of the actual breed(s) and their distribution, will remain uncertain.

III: ANCIENT EGYPTIAN DOGS

3.10 A Saluki called 'Brave', sitting under his master's chair, tomb of User, Dynasty XVIII.

3.11 A Saluki chasing ostriches from the base of Tutankhamun's fan, Dynasty XVIII.

Short-limbed hounds

Aside from the graceful sighthounds, there is some evidence that other types of hounds appeared in Egypt sometime prior to Middle Kingdom times. Both skeletal and pictorial evidence attest to the presence in Egypt of a short-limbed hound with erect ears and curled, cocked or hanging tails. In addition to the stocky dog depicted in the nautical rock art scenes, such hounds are clearly represented in the Dynasty VI mastaba of Mereruka (fig. 3.13) and the Dynasty XII tombs of Tehutihetep (El Bersheh) (fig. 3.13) and Chenemhotep (Beni Hasan) (fig. 3.12).

3.12 Three short-limbed hounds from the tomb of Chnemhotep, Dynasty XII.

3.13 Short-limbed dogs: (left) from the tomb of Tehuihetep, Dynasty XII, (right) from the tomb of Mereruka, Dynasty VI.

Mastiffs

Predynastic representations of a sturdy dog with short, massive muzzle, relatively long tail, and lop ears have been found at several sites including Hierakonpolis and Minshat Ezzat (fig. 3.14). These consist of some ivory heads, a sceptre head, a partial figurine, ivory statuettes and a slate palette (fig. 3.15).[11] It may be that the Predynastic depictions simply represent copies of Mesopotamian motifs rather than attempts to portray a real dog because evidence for the large and powerful mastiff in later periods is meagre. Examples of mastiff-type dogs have been reported from the tomb of Redmea [sic] at Thebes,[12, 13] a Dynasty VI offering scene,[14] and a Dynasty XVIII hunting scene in the tomb of Neferhotep.[15] Unfortunately, a review of these scenes suggests these identifications are questionable at best. Most of the depicted hounds look like sight hounds with a slightly heavier build, probably due to artistic license rather than adherence to biological accuracy. Nevertheless, based on limited skeletal evidence, it appears that mastiff-type dogs might have been introduced into Egypt from Mesopotamia (cf. figs 4.4, 4.6–9, 4.19) in small numbers by nomadic tribes and as tribute and existed in Egypt as exotic pets, but they did not survive as a breed because of the lack of sufficient numbers to establish a population.[16, 17]

3.14 Mastiffs from Hierakonpolis, Predynastic.

Detail from the palette in fig. 3.15.

3.15 Mastiff on a palette from Tell Ezzat, Predynastic.

Mongrels

Although pictorial representations of dogs adhere to certain physical standards, in reality most Egyptian dogs were mongrels, whose genetic background was the product of indiscriminate breeding between any number of domestic and feral forms. The term many Egyptologists use to refer to mongrels is pariah, although technically any stray dog, even a purebred, is a pariah.[18] If analogous to modern Egyptian mongrels (fig. 3.16), the ancient ones were most often buff coloured but could be black, white, or spotted. Skeletal measurements suggest that the average mongrel was smaller than the sight-hounds, although not necessarily more robust.[19] They appear nearly equal in size to the local wolf, their likely progenitor.

3.16 A pariah roaming a street in Egypt today.

Skeletal Evidence for Breeds

Many of the characteristics used to identify breeds from the artistic representations are soft-tissue traits, such as ears and tail position, and are not preserved in the skeletal record. Thus it is difficult to substantiate breeds based on these traits using the skeletal record. Skeletal remains can give us information regarding overall size and robustness, however, and thus some general categories can potentially be identified. Unfortunately, although thousands of dog remains have been reported from Egyptian archaeological sites, very few of them have been analyzed in any systematic way, particularly with regard to determining breeds.

For several of the above-mentioned breeds, only a few isolated skeletal examples exist. For instance, among 38 skulls of mummified dogs from Abydos, Thebes, and Asyut, one cranium resembles a mastiff skull. And dwarfed and deformed skulls have been reported from Asyut, Abydos and Thebes, possibly providing evidence for a small breed of dog.[20]

In a 1941 study of skeletal remains recovered from Predynastic and early Dynastic sites, (Abydos, Thebes, and Asyut), Hauck concluded that three major types of dogs existed in Egypt by early pharaonic times (around 3,000 BC): a greyhound-type sight-hound similar to those depicted in rock-art, a mongrel, and a tiny lapdog. The lapdog, however, could simply have been a dwarf or other aberrant form, but the mongrel and sight-hound parallel the findings based on pictorial representations.

In a 1903 publication, Lortet and Gaillard reported their findings on a number of dog skeletons that had been recovered from archaeological contexts. They concluded that four types of dogs existed in Egypt: a mongrel, a small dog with pointed muzzle (perhaps Hauck's lap-dog?), a 'greyhound,' and a hound they refer to as the 'Egyptian dog.' Exactly what criteria they used to come to this determination and which hound (tesem or Saluki-type?) they call an 'Egyptian dog' is unclear, but because Lortet and Gaillard took a number of measurements, modern researchers can use statistical tests to test the validity/reliability of their findings. Although myriad ways exist to statistically differentiate populations of dogs, shoulder height estimates have been proven to be a good indicator of general size. When one of the authors (Brewer) applied established formulae for estimating shoulder heights[21] to Lortet and Gaillard's data, the specimens fell into two distinct groups based on shoulder height (fig. 3.17). This is not to say that Gaillard and Lortet's conclusions are invalid, only that two types can be accounted for statistically and possibly three types if Lortet and Gaillard's

3.17 Diagram showing the shoulder heights of Egyptian dogs.

A t-test confirmed the statistical validity of a bimodal curve represented in the bar graph, suggesting two populations or types of dog (t,p>.05). The smaller population, with an average shoulder height of 45.66 cm, probably represents a population of mongrels, while the larger group, with an average should height of 50.73 cm (20"), could possibly represent a population of sight-hounds.

3.18 Diagram showing the shoulder heights of ancient dogs compared with modern ones.

identification of a greyhound is taken at face value.[22] These calculations, though conservative, suggest more than one type of dog existed in pharaonic Egypt.

Figure 3.18 provides shoulder height measurements from a series of dogs recovered from excavations in various parts of Egypt, the Levant and measurements from modern specimens. If this can be considered a representative sample of the ratio of mongrel to breeds, Lortet's Egyptian dog was quite rare and the Saluki-type even more so. Lortet's pariah nor his Egyptian dog reach the shoulder heights of their modern counterparts in Istanbul or the Levant. In fact, none of the specimens for which measurements exist, come even close to comparing with the measurements of modern Salukis, although numerous scenes show what appear to be Salukis hunting or in the company of their master. Based on the skeletal evidence, the most common dog in ancient Egypt was the ubiquitous mongrel.

That two independent lines of evidence — pictorial and skeletal — support the presence of different and identifiable canid forms implies that different dogs, perhaps maintained for different purposes, existed in Egypt by Dynastic times and that some notion of desired standards or breeds had been established by this period. At the very least, a population of sight-hounds had been separated from the mongrel, and very likely a smaller dog type existed as well. Although it is possible that these forms represent points along a continuum of canid shapes and sizes, statistical tests on skeletal remains and depictions in art suggest otherwise.

Dogs in Egyptian Society

Numerous tomb scenes show that dogs were much loved as pets and hunting companions (fig. 3.1). It is not surprising that these dogs had individual names — 77 have been recorded. The names refer to: colour – Blackie, Ebony; character – Good Herdsman, Reliable or Brave One (fig. 3.10); qualities such as speed – North Wind, Antelope. Foreign names for dogs also appear; many are thought to be Berber (e.g., *Beka*, meaning oryx) and some perhaps Nubian in origin.[23] In the first Dynasty we find a dog buried near his master under a tombstone with his name, Neb (lord), and picture carved on it. And King Antef II of the Dynasty XI was so proud of his four dogs that he not only had their names carved in relief on a stele (now in the Cairo museum), but he also had a statue-group of them, now lost, erected in front of his own tomb. In addition to their roles as pets and hunting companions, dogs served as watch dogs and police dogs. On one Middle Kingdom stele, a member of the desert police testifies that he patrolled the Western Desert in search of fugitives with the aid of five dogs. When he was subsequently promoted for his loyal service, the dogs' names and pictures were inscribed on the stele next to his.[24]

As a testimony of the Egyptian's love for their dogs, many were buried with human-like care. Thousands of dogs were found buried at Abydos; a special few were even provided with individual coffins bearing their own inscriptions.[25] One Old Kingdom stele mentions a royal guard dog, Abutiu (perhaps meaning 'with pointed ears'), which kept watch over his master. When the dog died, Pharaoh ordered him wrapped in a fine cloth dusted with incense and scented oil. Pharaoh also had a sarcophagus made for him, and he was buried in his own tomb. Such extreme devotion may have been exceptional, but erecting a stele over an interred dog was not atypical.[26] It is interesting to note, however, that although dogs were extended the highest honours in death, there are no representations of people petting or playing with their dogs.[27]

In contrast to the devotion shown to pets, hunting, and working dogs, feral dogs, or pariahs, were despised by the ancient villagers, an attitude that persists to this day. An excerpt from a Late Period text reveals that pariahs foraging on village refuse and acting aggressively to passersby were a common problem:

"If ever a flask of beer ... is opened, and people go out to get a cup, there are 200 large dogs...and they stand in readiness every day at the door of the house as often as I go out.... [What] if I had not the little [dog] of the royal scribe Nhihu here in the house. It is it that saves me from them again and again... ."[28]

Evidence for eating dog is confined to a single incident, which was a case of religious vengeance. Plutarch stated that "in my day the people of Oxyrhynchus caught a dog and sacrificed it and ate it up as if it had been sacrificial meat because the people of Cynopolis (dog city) were eating the fish known as the Oxyrhynchus (*Mormyrus* spp.)." As a result, they became involved in a war and "inflicted much harm upon each other," and it took the Roman army to quell the disturbance.[29]

Dog parts, however, were consumed or used in medical cures. For rabies, the liver of an infected dog roasted and eaten was supposed to protect the bitten from fear of water. The tooth of the offending dog put in a bag and tied to the arm of the victim was also supposed to act as a cure. Other cures call for dog organs or other parts, although not consumed. For example, the legs and dung of a dog, mixed with the hoof of an ass together with a number of other ingredients were used in an external application for relief of pain, for infections, eczema, and a remedy for baldness. The menstrual blood of a female dog was used for hair removal, and the genitals for preventing the whitening of the hair.[30]

Dogs in Religion and Symbolism

The dog, though a favoured pet of the Egyptians, appears never to have been regarded as a god, although great respect was paid the animal in the city of Cynopolis. Herodotus tells us that in "whatsoever house a cat dies of a natural death, all the family shave their eyebrows, only; but if a dog dies they shave the whole body and head. ... All persons bury their dogs in sacred vaults within their own city".[31] Budge further states that "if any wine or corn or any other necessity of life happened to be in a house when a dog died its use was prohibited; and when the body had been embalmed, it was buried in a tomb amid the greatest manifestations of grief by those to whom it belonged."[32]

The dog is not a major player in Egyptian mythology, but does have a role in several tales. If we accept the statement of Diodorus the dog was the guardian of the bodies of Osiris and Isis, and dogs guided Isis in her search for the body of Osiris, and protected her from wild beasts.

> "Anubis with a dog's head ... was the bodyguard of Osiris and Isis ... dogs guided Isis during her search for Osiris and protected her from wild beasts and way farers, and that they helped her in her search because of the affection they bore for her"[33]

Unfortunately, Diodorus, like many modern writers, probably conflated the dog with the jackal. That he confused the two is not surprising given that the Egyptians themselves did not always differentiate between dogs and jackals, sometimes using the same word for both canines. Nevertheless, myths and religious texts of all periods state that it was the jackal god who administered to Osiris and who acted as guide not only to him but also to every other Osiris in the Underworld.

In the tale of two brothers, the dog plays a more sinister role. When the elder brother discovers his spouse has plotted a sexual tryst with his younger brother, he kills her and casts her body to the dogs. "Presently he reached his home and he killed his wife, cast her [to] the dogs, and sat down mourning over his younger brother."[34] The dogs are the pariah hounds of the village, who it is assumed tear her body to pieces in a lust for food. Finally, in the incomplete story of the Doomed Prince, the prince meets his destiny through his life-long canine companion who apparently has plotted his master's demise from the very beginning. "Now [after some days had elapsed, the prince] went out to stroll about for relaxation on his property. [His wife] did not go out, but his dog was following him. Then his dog [took on powers of speech] saying, 'I am your fate'."[35]

Just as we do today, dogs and dog-like traits were used symbolically to represent both positive and negative aspects of human behaviour. When one Middle Kingdom official described himself metaphorically as "a dog who sleeps in the tent, a hound of the bed, whom his mistress loves," he was playing on the well-known faithfulness and loyalty of dogs. Patience and obedience were other traits associated with dogs, as in a New Kingdom scribal instruction which states, "the dog obeys the word and walks behind its master".[36] But not all dog characteristics had positive connotations. Conquered enemies parading before Pharaoh are reported by the Egyptian scribes to assert, "We are indeed your dogs," as a way to describe their cringing and servile nature. A similar negative statement comes from an artisan living at Deir el Medina: having erred, he confesses that the god Ptah "caused me to be as the street dogs, I being in his hand".[37]

Images of canids (or at least a dog-like canid) commonly appear on utilitarian objects, some of which may have served a symbolic function. Although authors disagree on what particular species these depictions represent, it appears that the jackal or domestic dog is the most likely subject represented. Most notable among the objects are the dog-like creatures that are shown biting a clam-shaped spoon or fish-shaped cosmetic case (fig. 3.3). Although jackal-like in appearance, the presence of a collar suggests the canid is a dog. Whether dog or jackal, Kozloff and Bryon point out some interesting uses of the motif and its parallels in Egyptian spells of the book of the dead. They believe the dog handle of the spoons represent the fingers of Isis as related in Spell 153 A.[38]

> "I know the name of its valve: it is the hand of Isis"
> "... as for the valve in my hand, it is the hand of Isis"[39]

The heads of dogs also decorate the ends of some of the better made senet-game casting sticks (fig. 3.19). The use of canine heads on gaming sticks is quite apropos since the canine headed god Wepwawet was the opener of ways to the after life, and the game senet was sacred to Hathor and integral to the deceased's safe entry into the next world. The sticks may be a metaphor for Wepwawet and his role in opening the way.[40] The image of a dog on the sticks may also be a pun relating to human toes. As early as the Old Kingdom, senet throw sticks were called *djebau*, a word meaning fingers and/or toes. Dog heads could thus be considered a metaphor for toes. Evidence for such a relationship is posed by Kozloff and Bryon who noted a carved human foot, located in a private collection, that possessed toes in the shape of a dog's head.[41]

3.19 Dog-headed gaming sticks.

Just as they are to us today, dogs were faithful friends, hunting companions and working partners to the ancient Egyptians. As evidence for their important relationship to humans, dogs were commonly featured in Egyptian art and popular stories and sayings, and they were well-cared for both in life and after death.

Notes
1. Winkler.
2. Osborn, Epstein.
3. Winkler, Epstein, Schweinfurth.
4. Flores.
5. Brunton, 41, Brunton and Caton-Thompson, 7, Debono 1950, 234-236, 1952, 634-638, Petrie, 33, Petrie and Quibell, 13, 16-17, see Flores for a review.
6. Osborn.
7. Tobler, pl. 37b, Frankfort, pl. iva, Hilzheimer 1932, Winkler.
8. Clark 1954, Epstein.
9. Because it is impossible to connect it with the modern Saluki breed without genetic testing, we will refer to it as the Saluki-type.
10. Osborn.
11. E.g., Quibell & Green, Boessneck 1988, Möllers & Scharff, El Baghdadi, for a review see Osborn.
12. Gwatkin 1933, Gwatkin 1934.
13. Gwatkin is proably referring to the Theban New Kingdom depictions associated with Rekhmire.
14. Epstein.
15. Osborn.
16. Hilzheimer 1908.
17. For more information on mastiffs in the Middle East see chapter IV, pp. 56–60.
18. See Osborn, 59, for a review of depicted dogs that have been designated as pariahs by various scholars.
19. Lortet & Gaillard 1903.
20. Hilzheimer 1908, Epstein.
21. See Harcourt.
22. Lortet & Gaillard's 'greyhound type' is represented by only one individual and therefore could not be included in a test of means. However, when compared individually to the proposed sight-hounds, the 'greyhound's', shoulder height is three standard deviations from the mean. The statistical probability that this dog belongs to the sight-hound group is less than one per-

cent. No comparable measurements were given for their small dog with pointed muzzle type, so modern statistical tests are unable to speculate on the existence of this form.

23. Janssen & Janssen 1989, Breasted I, 421.
24. Janssen & Janssen, 11.
25. Peet.
26. Janssen & Janssen, 12-13.
27. Montet, 65.
28. Caminos, 189.
29. Plutarch 5.380, 72.
30. Darby et al.
31. Herodotus 2.66-67.
32. Budge, II, 366.
33. Diodorus 1.87.
34. Simpson, 100; see also Lichtheim, II, 207.
35. Simpson, 90, see also Lichtheim, II, 202.
36. Janssen & Janssen, 11.
37. Janssen & Janssen, 10.
38. Kozloff & Bryon, 348-51.
39. Faulkner, 120, 121.
40. Kozloff & Bryon, 348.
41. Kozloff & Bryon, 349, fig. 76b.

CHAPTER 4

The Dogs of the Ancient Near East

Terence Clark

Many people today still find it hard to believe and some would really rather not know, even when confronted with overwhelming scientific evidence, that the gentle dog which follows them about with such unquestioning devotion is a comparatively recent descendant of the wolf, a creature whose very name is associated with savagery and cunning from our earliest childhood memories of Little Red Riding Hood. This relationship might appear even more extravagant if your companion is, say, a Chihuahua or a Pekinese than if it is a German Shepherd Dog, but small or large the link with the wolf is the same, though not necessarily with the same population of wolves. It is increasingly probable that dogs were domesticated at different times or simultaneously in various parts of the world from different types of wolves and began to diverge from one another at an early stage. The developmental route taken by our modern breeds from their historical origins has not yet been mapped and much of their history is obscured with mythology, if not pure speculation. Written accounts of them are often incomplete and obscure, pictures are exaggerated and stylised and skeletons are few and fragmentary.

The region around the Eastern Mediterranean bears ample witness to the earliest civilisation of man and his transition somewhere in the eighth millennium B.C. from hunter/gatherer wandering about Africa into settled farmer in Western Asia. It is reasonable therefore to look here for signs which might show how in the process man developed from wolves dogs with different characteristics and how dogs acquired the appearances of distinctive breeds, some of which may have continued into the present day. A conclusive answer to the question whether the evolution of specialised dogs, such as mastiffs and sighthounds, started in Africa and was carried over the land bridge of Sinai into the Levant and Mesopotamia or whether such dogs were the product of the settled civilisations in Asia which were taken to Africa as gifts, booty or companions may have to await further discoveries; but an examination here of the surviving evidence from antiquity up to the period of the Arab conquest of this whole region suggests some clues.

Mesopotamia and the Levant

The existence of dogs of what appear to be distinct breeds in Ancient Egypt is well illustrated from as early as the fourth millennium; whereas in Mesopotamia and the Levant the evidence is much harder to find. This may seem paradoxical because there is evidence to suggest that at least some of the breeds of Ancient Egypt probably derived from dogs that were introduced from Western Asia,[1] in particular from Mesopotamia. As Douglas Brewer has shown in Chapter I, that all dogs probably descend from wolves, which, apart from the highly specialised rodent-eating Ethiopian wolf (*Canis simensis*),[2] are not native to the continent of Africa, and contacts with Mesopotamia have existed from the earliest times. The explanation lies in the comparative lack of relevant archaeological remains from the great civilisations of Mesopotamia, where the materials used were for the most part less durable and withstood less easily the ravages of nature and of man, than from Egypt with its abundance of well-made and well-protected art.

Skeletal remains

There is a growing body of evidence to suggest that domestic dogs may have developed not from a single wolf population but at different times in different places from a number of different wolf populations. According to Wayne and others the archaeological evidence to prove this is still lacking but the circumstantial evidence and some experiments with the DNA of wolves and domestic dogs certainly points in this direction.[3] In Mesopotamia the oldest bones which have been for long identified as dog (*Canis familiaris*) come from modern Iraqi Kurdistan. A jawbone which is distinguishable from that of the wolf and is typical in shape of early domestic dogs was found in a late Palaeolithic cave at Palegawra, dating from about 12000 years ago,[4] but as is described in Chapter II (p. 23) some question whether it is really a dog's.

An early Neolithic site at Jarmo also in Iraqi Kurdistan, which had been occupied continuously for only a few hundred years between about 7000 and 6500 B.C., produced some 53 skull and jaw fragments of which 18 (only one skull and 17 jaw) were positively identifiable as domestic dog, while none was clearly wolf.[5] The animals had teeth as big as wolves' and, because of the proportions of the back part of the jaw, must have resembled closely such massive-headed breeds as the Eskimo Husky. This suggests that they derived from a local type of the northern wolf which was more massive than the smaller wolves of India (*Canis lupus pallipes*) and the Arabian Peninsula (*Canis lupus arabs*) (fig. 4.1). Research has shown that there are no clear-cut features of the skull by which these smaller sub-species of wolf can be distinguished from large domestic dogs but instead that there is definite overlap in all the characteristics regarded as reliable to distinguish dogs from northern wolves.[6] However some are sceptical

IV. THE DOGS OF THE ANCIENT NEAR EAST

about the Jarmo remains. Reed found no teeth or bones of dogs at the site in 1955 but pointed rather to cultural evidence for their domestication in the excavated figurines of doglike animals with jaunty upturned tails,[7] which could not have represented wolves. It is nonetheless surprising that if the dogs were worthy enough to have been modelled in this way, no bones survive. Reed speculates that if dogs were present, their bones must have been disposed of away from the village. This could have been because they were held in such esteem, which is supported by their reproduction as figurines, or possibly such loathing, as pariah dogs are today, that the carcasses had to be removed.

4.1: The Arabian wolf (canis lupus arabs).

Bone remains from the Natufian hunter-gatherer culture of the Levant from the Mesolithic period suggest a developing relationship, perhaps domestication, between man and dog/wolf[8] of a possibly different wolf population at about the same time c. 10,000 B.C. At Mallaha, near the old Huleh lake in the upper Jordan

valley, the skeleton of a puppy which had been buried with a human in a tomb is of particular interest as it indicates a relationship between canid and man which appears to have been based on affection. More recently a Natufian grave has been discovered in the nearby Hayonim cave containing the remains of three humans and two dogs which appear to have been buried under special circumstances to be identified with a rite.[9] Taking this bone evidence with that of other canid remains in the area and comparing them with modern local wolves, the pattern of slight reduction in tooth size and disproportionate shortening of the snout makes it probable that these early finds came from animals which had been subject to some degree of deliberate domestication. It is however possible that such changes in behaviour and shape could also have come about by unconscious selection as a consequence of environmental pressure on animal populations in and around human habitations. The process of selection in these very early dogs did not show in any appreciable lengthening of the limbs, like those of the Saluki, suggesting that they were not being bred for prolonged fast hunting.

4.2 Skeleton of a dog from Tell Brak, Iraq, c. 2,500 B.C.

Although the number of canine finds is increasing the amount of material is still relatively small. Until more substantial and incontrovertible evidence is discovered it is clear that the whole question of the early domestication of the wolf in the Mesolithic period in Mesopotamia and the Levant has to be approached with caution. The results of a dig at Qermez Dere in Iraq in 1986-90

are not encouraging in this regard.[10] The site dates from somewhere before 8000 B.C. and occupation continued into the first half of the eighth millennium. It straddles therefore the period of the transition from hunter-gathering to the domestication of selected plants and animals. Although more than 4000 fragments of animal bones were identified, not one of these was dog or wolf. Many of the bones showed signs of skinning either for the pelts or by way of preparation for consumption or both and included fox, hare and even cat but if there were dogs around they appear not to have been eaten or if they were kept for hunting, guarding or cultic purposes their remains were not buried at the site.

The earliest bones which are certainly of a breed of dog occurs only much later in Mesopotamia. While digging out the debris from a well at the great mound of Tepe Gawra about 15 miles North-east of Mosul in the period 1932-38, the Joint Expedition of the Baghdad School and the Pennsylvania University Museum to Mesopotamia found a skull of a Saluki at a level suggesting the pre-Sumerian period c. 4400–3800 B.C. From Eridu or Tell Abu Shahrain in southern Iraq, reputed to be the oldest city of Sumer, a skeleton "probably of a Saluki-type dog" was excavated in 1947 from a grave of a young boy in a cemetery dating to early in the fourth millennium B.C. The dog was found with a small meat bone near its mouth as sustenance for the after-world.[11] In 1987 a team from the British Museum under the direction of Professors David and Joan Oates found at Tell Brak in North-east Syria the complete skeleton of a dog dating from c. 2500 B.C. (fig. 4.2), on which Dr Juliet Clutton-Brock then of the Natural History Museum observed that it "may not have had the external features that characterise the Saluki but it was certainly of greyhound build". She obviously meant such characteristics as the long silky hair in the feathered variety, the long floppy ears and the hanging looped tail which did not survive burial over thousands of years. However she made a detailed comparison of the bones with those from 'Luman', a Saluki which had been imported from Egypt in 1897 by the Hon. Florence Amherst and whose skeleton was later presented to the Zoology Museum at Tring, and found striking similarities.[12]

Ritual burial of dogs

Recent excavations in the United Arab Emirates from the Umm an-Nar period c. 2300 -2100 B.C. shed some interesting light on the relationship between humans and dogs in the Arabian Peninsula.[13] In the largest tomb so far excavated in this area near the Shihuh village of Shimal at the foot of the Hajjar mountains in Ras al-Khaimah the articulated skeleton of a dog was found in 1997-98. The adult dog measuring 56.6 cm (22") at the shoulder appeared to have been deliberately buried near the head of a female figure and is the first such occurrence in

funerary practices of the period, though it is a practice of much earlier origin as the Natufian excavations have shown. While dog skeletons have been excavated in the Gulf from as early as the fourth millennium B.C., these burials appeared to be the remains of funeral meals, since the bones showed marks of butchery; whereas the Ras al-Khaimah skeleton bore no such marks. This suggests that the dog had been buried as a faithful companion. The Shihuh who inhabit these once remote and inhospitable mountains still observe in the *Nadabah* a curious link with dogs. The British explorer Bertram Thomas, while engaged as Adviser to the Sultan of Oman in the 1920s, described the custom: "Following an Arab meal of princely proportions, the Shihuh shaikh rose, and, standing a little aside with hands still unwashed – this I gathered was a necessary observance – placed his left arm across his chest and his right arm bent above and behind his head, then, straightening and bending the raised arm, he set up a curious howl not entirely unmusical, ascending and descending the scale of perhaps an octave... . Meantime, a dozen or so tribesmen standing close together in a ring about him with their hands to their mouths, "*muedhdhin*" fashion, broke in at intervals with a curious dog-like bark".[14]

Noteworthy, if only for the sheer number of carefully articulated skeletons – some 700 in separate shallow burial pits, is the dog cemetery uncovered at Ashkelon in Israel dating from the period 500–450 B.C., when the Philistines were ruled by the Phoenicians under the Persian Empire. A small number of similar burials was also found at nearby Ashdod. Nothing else was found to explain the burials, no cultic architecture or evidence of sacrifice; but it has been suggested that the Phoenicians were responsible and regarded the dogs as sacred, possibly associated with a healing cult.[15]

The ritual burial of dogs in association with a healing cult is certainly much older than the Phoenicians and dates back in Mesopotamia until at least 1000 B.C. At Isin in southern Iraq, in 1973 a German archaeological team uncovered a broad paved road leading to an area dedicated to the goddess Nin-isina, who was identical to the goddess Gula, known as "the great physician", during the reign of the Babylonian King Adad-apla-iddina of c. 1050 B.C. Under and by the side of the road they discovered 33 dog burials, some of them in linen bags: these are the earliest known ritual burials in Sumer. They also found bronze plates engraved with dogs, terracotta models of dogs, one of which was incised with a prayer to Gula, and a kneeling figure with his arm round a dog.[16] A detailed study of the skeletal remains drew some tentative conclusions about the types of dog.[17] They varied in age: one was still-born, 15 were puppies a few months old, 4 were up to a year old, 4 were one to one and a half years old and 9 were mature adults. Several of the adult dogs showed signs of healed fractures but there was nothing

IV. THE DOGS OF THE ANCIENT NEAR EAST

to indicate how or why they had come about. In size the full-grown dogs varied from 40 to 65 cm (16"–26") at the shoulder and the largest of them had the strong build of the mastiff, while two others were more of the Saluki build. If the accompanying representations on the copper plates are any guide, the other dogs may have had erect ears, medium length hair and a curly tail. However there was no conclusive evidence to show whether any of these dogs belonged to a specific breed.

Fuhr has assembled an impressive array of evidence to show the close relationship between Gula and her dogs, though it is an open question on what that relationship is based. By analogy with later Greek writings on the relationship of the dog to Aesculapius, it would seem likely that Gula's dog owed its position to the curative powers of its tongue and more particularly its saliva.

Artistic representations of breeds

4.3 Coins from Panormus

Pictorial evidence for the existence of particular breeds is somewhat less rare, though Dr Max Hilzheimer warned in his authoritative study that it needed to be handled with some caution when, as is often the case, the animals are represented without scale. He gives as an example: two coins from Panormus of the 4th century B.C. showing on each a muscular hound, one of which apart from its thick neck and prick ears might be likened to a Saluki, but there is no indication of its size. Even when written descriptions are given, the breed cannot be unequivocally identified.[18]

Drawing on Hilzheimer's study, Van Buren listed five breeds in the ancient world:[19]
- The Mastiff
- The Shepherd-dog
- *Canis familiaris* Studer (named after the Swiss zoologist Theophil Studer)
- Coursing dogs
- The Terrier and kindred types.

The Mastiff

4.4 (left) Stela of a mastiff in slips found near Babylon, Iraq, from c. 1750 B.C.
4.5 (right) Two modern Salukis in double slips

The Mastiff stood about 80 cm (32") at the shoulder and was heavy and generally smooth-haired, with small pendant ears. The breed's antiquity is vouchsafed in a variety of artistic representations. A small sculpture in black stone (steatite) of a recumbent mastiff which was found at Telloh (Lagash) in Iraq bears an inscription of Sumu-la-ilu, a king of Ur, who probably reigned towards the close of the third millennium B.C. The mastiff is shown equally graphically with its handler on a clay relicf plaque found at Birs-Nimrud near Babylon in Iraq, dating from c. 1750 B.C. Interestingly the dog is controlled both by a rope lead and a strap around the loins, much as a Slipper would hold Salukis in double slips today.

IV. THE DOGS OF THE ANCIENT NEAR EAST

4.6 Stone Achaemenid statue of a mastiff from Persepolis

Much later but even more impressive is the life-size sculpture in highly polished black stone of a mastiff from Persepolis now in the Tehran Archaeological Museum, which probably dates from the 5th to 4th century B.C. (fig. 4.6). Though its somewhat more leonine head suggests a certain degree of artistic licence probably to indicate ferocity, its general form equally suggests a remarkable continuity of the mastiff type over millennia. The various images show some differences in for example the length and shape of the tail and ears, possibly indicating that the breed was not entirely stabilised and capable of some diversity within local populations. Hilzheimer believed that the breed was still to be found in Central Asia in the 1930s. It may even bear some relation to the huge, fierce dogs, called Karabash or Ekbash, employed in Turkey today as guard dogs. Ekvall saw similar dogs to the Mesopotamian mastiffs among the nomads of Tibet: "They have the typical heavy muzzle, high domed head, hanging lips ... and massive forequarters of the mastiff breed"; but noted that they were invariably black and tan usually with some white on the throat and chest and they were used exclusively as watch dogs.[20]

Symons speculates that the Mesopotamian mastiffs may be identified with the "Indian dogs" mentioned by Herodotus[21] as having been kept by a Persian Governor of Babylon in the early 5th century B.C. for hunting onager, gazelle, deer and lynx. Unfortunately Herodotus does not describe them, though Ctesias says that they were so large as to fight against lions.[22] Assyrian reliefs from Ashurbanipal's Palace at Nineveh of c. 650 B.C. do indeed show smaller (60-70cm) (24–28"), leaner, less ponderous mastiff-type hounds involved in hunting lions, onager and gazelle (figs 4.7–8). Such hunts must have taken place inside walled enclosures where wild animals were released for hunting, rather as they do with hares in so-called park coursing in Eire, because these huge dogs could not have otherwise caught such fleet-footed game in the open. Identical mastiffs are also shown in battle in these reliefs, though a frieze from Pergamum from the first half of the 2nd century B.C. shows a different type of war-dog accompanying Hecate, with a rough coat, short muzzle and erect ears (fig. 4.9).

However Balles has interpreted Herodotus' Indian dogs to have been greyhounds, which Cyrus the Great's son Cambyses took with him on his expedition to Egypt, thereby introducing 'Persian greyhounds' there more than 1000 years before the Arab conquests.[23] Balles draws a distinction between these Persian greyhounds and the Arabian Saluki, whose existence in Egypt does of course long pre-date Cambyses. The evidence for this interpretation is however contradictory. On a purely factual point, Cambyses did not invade Egypt until more than a century

IV. THE DOGS OF THE ANCIENT NEAR EAST

4.7 Ashurbanipal's Mastiffs on leads.

4.8 Ashurbanipal's Mastiffs bringing down onager.

4.9 Assyrian war-dogs in a frieze from Pergamum.

later than she claims. Moreover Xenophon makes it clear that Indian hounds were boarhounds and were therefore large enough to deal with this powerful prey.[24] However a painting now in the Victoria and Albert Museum shows Mahrana Jawan Singh (1828-38) of Mewar in full pursuit of wild boar with a pack of powerful Salukis at Udaipur in India.[25] So it was clearly not necessary for the hounds to have been of mastiff stature to hunt boar. If Indian hounds were nonetheless mastiffs they could not have been introduced by Cambyses as they had already reached Ancient Egypt with invaders or as gifts as early as about 3000 B.C. but seemed to have died out subsequently (p. 37). Hilzheimer attributed their extinction to lack of further stock but that is surprising in view of the long-continuing relations between Egypt and the civilisations of Mesopotamia. Indeed the Assyrians, who may have had their mastiffs with them, invaded Egypt in the period 671–669 B.C. and were expelled only in 655 B.C.

Shepherd Dog
The Shepherd Dog stood over 65cm (24") high at the shoulder, with a flat-topped head, pointed muzzle, low forehead, and hanging ears; the hair was either curly, wavy, or rough, never smooth. This was a dog for guarding flocks rather than a sheep-dog for herding them. Van Buren quoted Hilzheimer as believing it derived from the same stock as the Tibetan sheep-dog and was brought to Mesopotamia via Elam. There is clearly some confusion here, as Hilzheimer's study nowhere said as much; indeed he said specifically that it is erroneous to connect this breed with the so-called Tibetan dogs. However the mid-19th century British archaeologist Austen Layard may have started this story since he is credited with linking the Mesopotamian mastiff with Tibet:[26] but Ekvall emphasised that the Tibetan mastiff and an equally large mongrel he found there

were watchdogs only and were not used in any other role with regard to their nomadic owners' livestock.[27]

4.10 A modern guard dog in Iraq.

Canis familiaris Studer

This was big and heavy, with small prick ears, a curly tail and generally a smooth coat. It was frequently represented in different Mesopotamian art forms, particularly in neo-Babylonian times of the first millennium B.C., often in association with the goddess Gula on *kudurru* or boundary markers (fig. 4.11).[28] These conical blocks or boulders were set up on landed estates not so much to mark out the boundary itself but to describe in the inscribed text the limits and orientation of the estate. The dogs are also commonly depicted on cylinder seals to illustrate the myth of Etana's courageous but vain attempt to ascend to heaven on the wings of an eagle. They are usually shown singly or in pairs sitting facing each other and gazing up into the sky. Such dogs were also modelled, often very crudely, in clay and one found at Sippar from the late-Babylonian period bears a dedication to the goddess ME.ME., a divinity assimilated to Gula. Van Buren associated this type with dogs which were modelled in precious metals and in bronze and buried under the threshold to protect the house or palace from malign influences, though Green said it was unclear whether they might not have been rather dedicatory.[29] The small bronze sculpture from Babylonia of the 7th–6th

IV. THE DOGS OF THE ANCIENT NEAR EAST

4.11 Gula's dog on a kudurru, *boundary marker, 1ˢᵗ Millennium B.C.*

century B.C. of a person in a cowled tunic drinking from a beaker with his left arm round a large seated dog with stubby erect ears and a short curly tail does indeed appear more dedicatory.

4.12 Bronze figurine from Nineveh.

Six identical little bronze dogs were found in the Assyrian capital of Nineveh; and at Ur, in the palace built by Nabodnidus (555-539 B.C.) for his

IV: THE DOGS OF THE ANCIENT NEAR EAST

4.13 *The ancient hunt, from a Roman mosaic from Oudna, Tunisia, 3rd century A.D.*

4.14 *The modern hunt, coursing with Salukis in Morocco*

4.15 *The hound, tribal Saluki in the Empty Quarter.*

64 IV: THE DOGS OF THE ANCIENT NEAR EAST

4.16 Home from the hunt, fragment of a Roman mosaic from Cartinage, Tunisia, early 4th century A.D.

4.17 Huntsman with hound and gun, Morocco.

4.18 Home from the hunt, Syria.

IV. THE DOGS OF THE ANCIENT NEAR EAST

daughter, the high-priestess Bel-salti-nannar, two little bronze dogs were discovered at the base of a wall in one room, and two more in another room, one having its face covered with gold foil (fig. 4.12). According to Green Assyrian cuneiform tablets have been found prescribing that ten model clay dogs should be buried, five on one side of the doorway and five on the other, with their names inscribed on them for the purpose of keeping away evil demons and ghosts that brought misfortune, sickness and death. Long and complex rituals were necessary to give their magical properties. The models were first coated with a wash of lime and then each pair was painted in one of the five magic colours: white with red spots, black, red, green-blue or yellow-white. Layard discovered a half-set of five such terracotta dogs in a niche at the base of a doorway slab in the North Palace of Ashurbanipal (668-631 B.C.) at Nineveh (fig. 4.18). One had his name *mushetsu lemnuti* (Banisher of Evil) written on his shoulder in cuneiform.[30] Others had names such as "Enemy catcher", "Enemy biter", "Don't think, bite!", "Consume his life!" and "Loud barker".

4.19 Assyrian terracotta figurine of a dog with a cuneiform inscription.

At Ur a set of five sitting dogs, one still with traces of red paint on it, was found in a brick box under Nabodnidus' daughter's palace in addition to the four mentioned above. At Kish three clay figurines, possibly part of a set of five sitting dogs were found under the floor of a room in the 'Library'.[31] Three clay dogs from an even earlier period had been buried just outside the south wall of the hypogeum built at Lagash by Ur-Ningirsu and Ug-me, the son and grandson of Gudea.[32] Now Green likened these clay dogs to "mastiffs of the royal hunting breed" rather than to Van Buren's *Canis familiaris* Studer. They are clearly different from the smooth-haired mastiffs described above but equally their

IV. THE DOGS OF THE ANCIENT NEAR EAST

distinctive mane makes them look more like the rough-coated war-dogs of Hecate than *Canis familiaris* Studer.

Given its rather elevated status, it is surprising that Hilzheimer related this breed to a contemporary pariah dog from Libya. He claimed to see a resemblance between the pariah and hounds hunting boar shown in a fresco (Helladic III) at Mycenaean Tiryns (fig. 4.20); whereas the hounds actually look much more like a parti-coloured Saluki from Egypt such as that which is thought to have come from Malkata (fig. 3.9). Salukis of this type are still used for hunting boar in Morocco. In fairness, however, he did say that in build these pariah dogs, standing about 50 cm (20") high, usually of a reddish or yellowish colour and varying from smooth to wire-haired, with long muzzles, sloping brow, erect ears with the points often drooping, and the tail more or less tightly curled, ranged widely from a very heavy lumpish Pomeranian to the hound or sheep-dog types and even approached very nearly to the light build of the greyhound. The question is whether the pariah is a wild dog which was given status as the consort of gods or is it merely a mixture of ancient breeds gone half-wild? Hilzheimer

4.20 *Hounds on a fresco from Tiryns, Greece, around 1300 B.C. These piebald dogs are reminiscent of the Egyptian hound in fig. 3.9.*

IV. THE DOGS OF THE ANCIENT NEAR EAST

inclined to the latter view on the grounds that it evolved in highly developed countries in antiquity which were overrun and destroyed by invaders, when their dogs which had been bred carefully for centuries were left to run wild. Certainly today such dogs breed indiscriminately but still show the same wide range of types from the ubiquitous shaggy guard dog to be found round any village in Iraq (fig. 4.10) to the lean, smooth feral dogs of Oman which have more than a touch of the Saluki about them (fig. 4.21).

4.21 Omani smooth feral hounds.

Coursing Dogs

These were generally smooth, short-haired animals with slender bodies set on long legs, pointed heads, either small pointed or larger floppy ears and a long thin tail. It is one of the most frequently represented of all the breeds and clearly held a position of some esteem both as a valuable hunting hound and as a companion

of the gods. The earliest representation is of a Saluki-like hound on a leash appearing on pottery from the Halaf period (5300-4300 B.C.).[33] A seal impression in sun-dried clay from the Chalcolithic period c. 5000 B.C. at Tell Arpachiya in Mosul reveals "some kind of coursing dog, perhaps a greyhound".[34] About 300 seals and seal impressions found at all levels at Tepe Gawra show many dogs in hunting scenes and the excavators commented: "The animals depicted are rarely of any domesticated variety, except for the commonly represented Saluki" (fig. 4.22).[35] Similar seals and seal impressions were also found at other Assyrian sites at Nineveh and Kuyunjik.

4.22 Seal impression of the hounds from Tepe Gawra c. 4,000 B.C.

A pottery beaker in the Louvre (figs 4.23-4) and a vase in the British museum of c. 4000 B.C. from Susa in Iran (fig. 4.25) also show similar lean hounds of the Saluki type in conjunction with some kind of wild goat, probably the bezoar goat (*Capra aegagrus*), which is still found in mountainous areas from Asia Minor to Sind in India. Morris speculates that the canine with the bristly coat and straight tail on the vase may be a shaggy wolf; whereas the other two canines have smooth coats and tails curled over their backs and are clearly hunting with a man with a bow and arrow: indeed one of them is held by him on a leash.[36] The hounds on the beaker are even more sketchy but clearly of a Saluki type. The fact that the tail is curled high does not necessarily indicate that this was the normal carriage, since the Saluki, which naturally carries its tail low, will raise it over its back when excited or on the attack, as depicted on the vase. It is moreover common practice in parts of former Mesopotamia for Salukis' ears to be cropped so that they stand up and it is possible that this is an old tradition that might have been reflected in the early artistic representations of these

THE DOGS OF THE ANCIENT NEAR EAST

4.23 (left) Detail from a beaker from Susa
4.24 (right) Detail of long-dogs on a beaker from Susa, c. 4,000 B.C.

4.25 Drawings of hounds hunting goats, Susa Iran, c. 4,000 B.C.

animals (4.25). Certainly in Arabia in pre-Islamic times it was common practice to cut off or slit the ears of certain animals which had been dedicated to pagan deities in order to distinguish them from those which had not. Although various commentators on the reference to this practice in the Qur'an (Sura IV, 119)[37] do not include dogs among these animals it may be that cropping dogs' ears had its origins in some pagan belief. Contemporary practitioners offer a wide variety of explanations: for beauty, speed or alertness and for preventing damage in fights or from thorn bushes; but the probability is that it is merely for identification or the continuation of an old custom the origin of which has long since been forgotten.

4.26 Modern Saluki in Syria with cropped ears

However a small figurine in copper, only 6cms high, excavated at Tell Aqrab near the Diyala river east of Baghdad dating from the Sumerian period of c. 3600 B.C. clearly shows a Saluki with long floppy ears.[38] A Saluki-type hound in a sitting position is shown on a cylinder seal from the first Babylonian dynasty of c. 1900 B.C. as an associate of Gula, notably different in type from the more robust hounds usually depicted. While this hound's ears seem to project backwards, they are certainly not erect.[39]

The Terrier

Terriers and kindred types are small dogs with a curly tail, either short haired or feathered. One variety looked like the modern Pomeranian, which is itself probably descended from the ancient Torfhund of northern Europe. It is often represented however in a hunting role. A gypsum cylinder seal attributable to the Jemdet Nasr period (c. 3000 B.C.) which was found below the 'White Temple' at Warka in southern Iraq shows a hunting scene in which two men are preceded by a small dog with pointed ears and muzzle and a tail curled over its back. Glazed steatite figurines of similar dogs from the same period, which were used as amulets with their tails of wavy hair curled over their backs, were found at the Temple of Sin at Khafajeh. On a seal impression from Farah men herd cattle and a small dog with a plumed tail appears to leap forward as if protecting the herd from predators. Other similar dogs appear on Sumerian cylinder seals and in the friezes of shell inlay from the palace at Kish and Bismaya. Crude clay figurines from various periods were found on many excavated sites and have been likened to terriers because of their pointed muzzle and ears and a tail sticking straight up.[40] Such small dogs are still to be seen in Iraq today, where they go by the name of 'Boojy' and seem to be used with cattle and as a gun dog for retrieving shot birds.

Written evidence

In the earliest written records in Sumerian cuneiform there are two basic words for dog: *ur* and *ur-gi*.[41] Whether there was a difference of meaning between them is not clear, but *ur-gi* can have the meaning of "noble beast" or "princely beast", a sense which may have been carried forward into Arabic, where the Saluki is concerned, which is often described as *Saluki Asil* (a Saluki of pure or noble origin). *Nig* meant bitch and *ur-tur* and *amar-ur-gi-ra* meant puppy. However *ur* could also mean lion and was used to make up composite words, such *ur-gi-ku* for dog-fish or shark.

In the later Akkadian language of the second millennium B.C. dog became *kalbu*, while bitch was *kalbatu* and puppy *miranu*. The parallel with Arabic is obvious, viz. *kalb* and *kalbah*, though puppy is *jaru*.

The word *ur* was sometimes linked with a place name to indicate a specific type of dog or possibly a breed, e.g. the Elam-dog or Shepherd Dog, referred to by Van Buren above. It was also linked with the word for certain colours, possibly indicating breeds, e.g. the Shepherd Dog (*ur-nam-sipa-da*) is described as black. A red dog from Meluhha (possibly the ancient name for India) was presented as tribute to King Ibbi-Sin (c. 2025 B.C.), its description as *ur-nigin* (Sumerian) or *sa'idu* (Akkadian) indicating that it must have been some kind of a valuable

purebred hunting dog, possibly the Saluki or the Mastiff in view of the connection with India (see above). It is also a noteworthy coincidence that *sa'id* in Arabic means hunter and is a name sometimes given to Salukis, though the form *sayyad* is more common.

Some of the Babylonian economic cuneiform texts from Ur confirm the roles of the different types of dogs. Their value can be to some extent measured by the amount of food they were given: a daily ration of two litres of barley flour for making into bread and three talents of fish – as much as their handlers received. Another text from Mari from 1800 B.C. refers to an even more generous ration of 12 litres of grain for two dogs of the Mastiff type. That they lived not from bread alone is clear: in Ur they not only scavenged the rubbish and excrement but disposed of the bodies of dead animals much as hunting packs do in this country today. They also guarded against thieves and wild animals and protected the livestock. Curiously the Babylonian texts say little about their hunting role from which it might be concluded that it was unimportant; yet this is difficult to reconcile with the prominence given to hunting with dogs in the neighbouring empire of Assyria. Their medical role is somewhat ambiguous: on the one hand they are described as having the power to cure by licking wounds and infections, while on the other their bite was regarded as poisonous and potentially rabid.

Later developments in Mesopotamia

In 612 B.C. the palaces at Nineveh, with their splendid reliefs of hunting scenes, came crashing down in flames as the Assyrian Empire collapsed under the combined attack of the Babylonians with their allies the Medes. The neo-Babylonian renaissance was however short-lived as in 539 B.C. it too gave way to pressure from the East in the shape of the Achaemenian Cyrus the Great, though he spared Babylon and its inhabitants from destruction and indeed restored some of its temples to their previous glory. Cyrus' son Cambyses ruled as Governor of Babylon from 538 B.C. until he succeeded his father as King of Persia in 529 B.C. It was during this period that he emulated the Assyrians a century earlier by invading Egypt, accompanied by large numbers of his Indian dogs, whatever they might have been (see p. 58). After his death the Achaemenians' benevolent attitude towards Mesopotamia changed and as a result of a combination of repression, heavy taxation and neglect the region went into serious decline, so that when Xenophon travelled there in 401 B.C. with 10,000 Greek mercenaries he saw nothing but ruins and desolation where once great cities had been. Seventy years later Alexander the Great burst upon Mesopotamia and conquered Babylon. Alexander loved hunting, as we know from his chronicler Arrian, and it is reasonable to assume that he brought in his train dogs of the various breeds that Xenophon and Arrian describe the Greeks as

having.[42] It is also reasonable to assume that he availed himself of those of the indigenous dogs that had survived the decline, including notably the coursing hounds whose description by Arrian so closely resembles that of the Saluki (see p. 89). Alexander did not live long enough to enjoy his conquests in Asia and died in Babylon in 323 B.C. After a period of confusion as Alexander's generals fought each other for control of his vast territories, Seleucus, chief of the Macedonian cavalry, emerged as the ruler of an empire that stretched initially from Egypt to India and the Black Sea to the Persian Gulf and established the Seleucid dynasty, which continued in an ever-dwindling area mainly in modern Iraq and more particularly Syria until its overthrow by the Romans in 63 B.C. It has been argued that it is to the Seleucid (Salūqī in Arabic) empire that we owe our word Saluki.[43] If so, it is reasonable to assume that this hound must have regained its former position of distinction in the area for people to associate it with the ruling dynasty.

But was this hound the same as we have known in the past century or two or could it possibly have been something different? Some recent research by Dr John Mattock of Glasgow University[44] has revealed scope for doubt. As we shall see in the next chapter, various of the classical writers refer to the Laconian hound. Aristotle, for example, refers in several places in his *Historia Animalium* to these hunting hounds but we do not know exactly what they looked like. They may have resembled the most frequently depicted but unnamed short-haired, prick-eared hound or Laconian may have been used in a general way to describe any distinctive hunting hound. A clue might lie in how the Arabs translated Laconian in their works based on those of the Greeks. The problem was to find an Arabic translation of a Greek work in which Laconian appeared. After a number of false or interrupted trails a 17/18th century A.D. manuscript in Arabic, based on Aristotle's book was located by Dr Mattock at Glasgow University. It is made from an original manuscript in the Library of the Majles in Tehran (MS Tabatabai 1143), which seems to be based on a much earlier manuscript, probably from the late 8th century A.D. Dr Mattock set about comparing the Greek text of Aristotle with the Arabic manuscript with the result that wherever Laconian appears it is translated by al-Kalb al-Salūqī (Saluki dog) in the masculine, al-Kalbah al-Salūqīyyah in the feminine and *al-Kilab al-Salukiyyah* in the plural. This research opens up however more questions than it answers. Did the Arab translator merely substitute Salūqī for Laconian because *Saluki* was the only hunting hound known to the Arabs? Was the Arab translator indeed acquainted with the true Laconian hound and knew it to be the *Saluki*? For the present we can only continue the search for further clues.

4.27 Rock engraving of a hound and attacking an ostrich in Southern Jordan from around 100 B.C. – A.D. 200.

Rock art from Wadi Judayyid in southern Jordan dated to the Nabatean period somewhere between the 1st century B.C. and the 3rd century A.D. showing a Saluki attacking an ostrich (fig. 4.27) gives some idea of the range of this hound.[45] Another undatable petroglyph from Shiraz shows a Saluki-like hound riding to the hunt on the crupper of a horse while another, possibly on a leash, attacks a striped creature, possibly a hyena (fig. 4.28).

4.28 Petroglyph of a Saluki riding behind his master.

However in South Arabia at this time a somewhat different type of dog was used for hunting Ibex, a practice which continues until this day.[46] According to Sergeant, 'Inat is famous for its own breed of dog, which the local people treat kindly much as the Bedouin further north treat their Salukis and for similar reasons: the dogs are good hunters and of great assistance to the people in

catching the Ibex. These dogs were described by local shaikhs as of the breed of Qitmir, which is the name given to the dog mentioned in a story in the Qur'an as belonging to the youths known in the West as 'the Seven Sleepers of Ephesus' (Sura XVIII). The shaikhs were clear that they were not different from the usual pariah dog in appearance and were definitely not Salukis. A bronze lamp from Matara in Eritrea, now in the Addis Ababa Museum, of a type also found in Yemen supports this description. It has a handle composed of a dog standing on its hind legs to seize a leaping Ibex by a back leg.[47] The smooth coated dog has erect ears and a broad head with strong jaws, very like the pariah dogs to be found around Saiyun in the Wadi Hadhramawt (fig. 4.29. A stone stele now in the Saiyun Museum (fig. 4.30) shows such dogs attacking an Ibex and a similar one is in the Sana'a Museum. The dogs are released in packs and seize the Ibex by the testicles so that it cannot move until the hunters arrive to dispatch it. The dogs are also used to carry messages back to their village in the form of notes tied to their neck about the results of the hunt.

4.29 A pariah dog in the Wadi Hadhramawt.

4.30 Stela of hounds attacking an ibex, Wadi Hadramawt c. 1–3rd century A.D. B.C.

4.31 Detail from a mosaic in the Roman theatre Bosra, Syria 2nd century A.D.

4.32 Detail from a mosaic from the baptistery of the church of Mount Nebo, A.D. 531.

4.33 Detail from a mosaic from Mukhayat, Jordan, late 6th century A.D.

The Romans in the eastern part of the Empire were also enthusiastic hunters and used both their own dogs and the indigenous Saluki as is evidenced in the mosaic from the second century A.D. now erected in the amphitheatre at Bosra in Syria (fig. 4.31). The Byzantines shared the same passion and left their tribute to hunting in such remarkable mosaics as that known as the "Animal Chase" once in the floor of a church at Huarte in Syria dated to 472 or 487 A.D. and now in the museum at Apamea in Syria or that in the floor of the church at the place called Siyagha at Mount Nebo in Jordan from 531 A.D. showing a Saluki accompanying a horseman on a boar hunt (fig. 4.32). At nearby Makhayat there is a fine almost intact mosaic in the floor of the late 6th century church showing a smooth Saluki coursing a hare (4.33).

At this time Mesopotamia was being torn apart during centuries of strife between the Romans and later Byzantines and the Sassanians from Persia so that by the early 7th century A.D. its ancient cities had fallen in ruins and much of the countryside had been abandoned. Both the Byzantines and the Sassanians employed Arab tribes as buffer guards to keep out the marauding nomads from the adjacent deserts whose harsh way of life included hunting with hounds. The poetry of this period, known in Arabic as the *Jahiliyyah* (Ignorance), is rich in references to hunting the Oryx with hounds whose description fits that of the Saluki.[48] However these same tribes were soon fired by the religious fervour inspired by the Prophet Muhammad and by the middle of the 7th century had united behind the banners of Islam to sweep the Byzantines and Sassanians from Syria and Iraq before going on to conquer the whole of North Africa, Spain, part of France, Persia, and large parts of Central Asia.

Islam undoubtedly changed significantly the relationship between the Arabs and their dogs, on the subject of which there is some ambiguity in the *Hadith* (Traditions of the Prophet), over the interpretation of which the schools of Islamic jurisprudence differ.[49] Muslims were enjoined by the Qur'an (*Sura V – Al-Maidah*) to eat meat which had been ritually slaughtered (*Hallal*), for which the sole exception was what was caught by trained beasts and birds of prey, provided that it had been blessed in the name of Allah before their release for the chase and that they had not attempted to eat or mutilate it. The Bedouin appear to have interpreted this as an exemption for their hunting hounds from the category of *Najas* (unclean) animals, with which Muslims were enjoined to avoid close contact, as they needed by definition to be handled by their master and to this day they continue to have a degree of familiarity with their owners usually denied to other dogs. According to the *Hadith*, the Prophet at one stage in Medina decided that all dogs should be exterminated, in the belief that they constituted a threat to public health, but later modified his decision because dogs were among Allah's

creatures and certain of them were useful to man – such as hunting hounds and other dogs trained for herding, shepherding and guarding. However even these privileged categories were still to be regarded as unclean in the context of Islamic ritual purity, though as mentioned above the Bedouin at least have tended to be less rigorous in this regard where their Salukis are concerned. The cull was then curiously limited to black strays, particularly those with light "pips" over their eyes, since they were the mark of the devil. Fortunately for black and tan Salukis this prohibition was not continued and such hounds are accepted today as hounds of any other colour.

By the close of the first millennium A.D. indigenous and foreign dogs of different types were being used widely across the Middle East for various roles. We might continue to speak of some of them as breeds. Indeed Al-Jahiz in his monumental work of the 9th century A.D. on animals called *al-Hayawan* refers in one heading to *Asnaf al-Kilab* which may be translated as breeds or types of dogs.[50] Principal among these was the Saluki, no doubt because it was the most frequently mentioned breed in the hunting poetry and prose of the time. Indeed Al-Jahiz says that it was the only hunting hound that the Arabs knew and it was of the noblest. However it was not the only breed. The Saluki was crossed with the Kurdish sheepdog to produce a *Khilasi*, a cross-bred with a good nose for scent. This was clearly regarded as of a different order from the *Khariji*, a mongrel. It is interesting that in the Arabian Peninsula today *Khariji* is a term that is sometimes applied to imported Greyhounds, though probably in its more common meaning of "foreign", to distinguish them from local Salukis. Al-Jahiz recognises other breeds such as the *Zi'ni*, a type of basset sheep dog, and the *Sini*, a type of Pekinese or pug whose very name indicates it came from China (*al-Sin*). Another breed of foreign origin was the *Zaghari* or *Zughari*, a type of Pointer which is believed to have come from Germany with the Crusaders,[51] or possibly according to some Arab sources, from Byzantine territory called Zaghur.[52]

In the Middle East today it is hard to recognise any of these breeds. The Saluki is the exception. It may well have been crossed here and there in its long history but its breeders have continually bred back to its functional type to present a hound which in all essential characteristics is of the same type as was known to the early peoples of Mesopotamia. The Kurds too still breed a type of mastiff guard dog not unlike those on the sculpted reliefs from the palace of Sennacherib at Nineveh. They also breed a handsome hairy sheepdog something like the Hungarian *Kuvasz*. In some parts of the Middle East where shooting birds is more popular than coursing, small often red and white Pointer/Retrievers can be seen but whether they are the descendants of the old *Zaghari* or of more recent imports is hard to say.

Conclusion

It is disappointing that while the frontiers of the origins of man are constantly being pushed further and further back into antiquity we are still dependent on such a limited range of bones and art to illuminate the origins of his earliest animal companion. Such evidence as exists does however point quite clearly to the domestication of dogs from wolves in Western Asia sometime around 12,000 years ago. It then seems to have been a long slow process of natural evolution or deliberate development or both before distinct breeds or types begin to occur as skeletal remains or in art forms about 6,000 years ago. Further archaeological discoveries may yet fill in some of the gaps but for the present the skull bones identified as those of a Saluki from Tepe Gawra in Northern Iraq are the earliest recognisable remains of a distinct breed, pre-dating anything so far discovered in Egypt. This might suggest that this type of hunting hound appeared first in Mesopotamia but whether it spread to Egypt or whether a similar type of hound was also developed there to meet a similar need remains unknown. It is of course possible that such hunting hounds were first developed elsewhere in Central Asia but if so no remains have yet been discovered and for the present Mesopotamia seems the most likely origin.

Once we move into classical times the relatively small number of breeds identifiable in Western Asia and North Africa begins to expand rapidly in the civilised societies of Greece and Rome, as the next chapter shows. However this expansion did not leave a lasting impression in the Middle East and by the time Islam had swept away the last traces of their Empires the Arabs were left only with the Saluki as a purebred hound much as their ancestors had had in antiquity. It is to their credit that it has remained with them to the present day.

Notes

1. Daub, 18.
2. Sillero-Zubieri, 14.
3. Wayne 1997, 1687–9.
4. Turnbull & Reed, 81–146.
5. Lawrence 1983, 485–489.
6. Reed 1960, 126.
7. Reed 1960, 128.
8. Davis 1978, 608–610.
9. Tchernov 1997, 65–95.
10. Dobney, 47–57.
11. Lloyd, 18 & pl. IV.
12. Clutton-Brock 1989, 219–220.
13. Blau 34–42.
14. Ward 464–5.

15. Stager 2642.
16. Fuhr 135–45.
17. Boessneck 1977, 97–102.
18. Hilzheimer 1931, 3–14.
19. Van Buren 1939, 14–18.
20. Ekvall, 167.
21. Herodotus, 1.192, 7.187.
22. Stein, 214 n. 19.
23. Balles, 842.
24. Xenophon, 10.4 & n.
25. Waters, 43
26. Handcock, 18.
27. Ekvall, 168.
28. King i, xv.
29. Green, 116.
30. Symons, 12.
31. Van Buren, 1939, 56, fig. 36.
32. Parrot, 54.
33. Waters, 13.
34. Mallowan, 99.
35. Tobler, 32.
36. Morris, 15.
37. Ali, 234.
38. Clark 1995, 134.
39. Frankfort, 177.
40. Van Buren 1939, 15–16.
41. Real. IV, 494–7.
42. Phillips, 33–127.
43. Smith, 86.
44. Personal correspondence.
45. Clark 1995, 158.
46. Serjeant, 32–3.
47. Serjeant, Pl. 1.
48. Blunt, 28.
49. Smith, 90–2.
50. Al-Jahiz, 533.
51. *E.I.* 491.
52. Ahsan, 212.

V: DOGS OF THE CLASSICAL WORLD

5.1 Marble statue of the Molossian type, Roman copy of a Hellenistic original

5.2 Salukis going off to the hunt, detail of a Roman mosaic from El Djem 4ᵗʰ-5ᵗʰ centuries A.D.

5.3 Detail of a Roman mosaic from El Djem of a hunt with various hounds including docked boar hounds and Salukis, 3rd century AD.

5.4 Detail from a fresco of a lap-dog, Pompeii, 1st century AD.

CHAPTER 5
The Dogs of the Classical World
Adrian Phillips

"For what human being more clearly or more vociferously gives warning of the presence of a wild beast or of a thief as does the dog by its barking? What servant is more attached to its master than is a dog? What companion more faithful? What guardian more incorruptible? What more wakeful night-watchman can be found? Lastly, what more steadfast avenger or defender?"
Columella 7.12.1

We have seen in the preceding chapters how the wolf became the domestic dog and how distinct breeds were evolved by the fifth or perhaps the fourth millennium B.C. in Egypt and Mesopotamia. Domestic breeds may have developed elsewhere at the same time or even earlier, but they have left little evidence. A more precise dating is difficult because, as has been made clear above, the evidence is based upon the archaeological remains, both bones and artefacts, and the earlier these are the more difficult they are to identify with any certainty. But when we look at the Gaeco-Roman world we can add to this the written word. Granted that in Egypt, for example, the names of many hounds have been recorded (p. 43) but the Greeks were the first to write manuals about dogs; a practice which was continued by the Romans.

If a breed is defined as a deliberate selection by man of desirable characteristics for its function both of physique and temperament which are fixed through succeeding generations (p. 25), then we need to be careful when talking of breeds in the ancient world particularly when one is considering so long a timescale. Our contemporary breeds change rapidly according to the dictates of fashion. In the classical period, which we might define as that from the rise of classical Greece, particularly Athens in the fifth century B.C. to the end of the Western Roman empire, we are spanning over a thousand years. So it would be remarkable if, for example, the Laconian hound retained the same conformation throughout a whole millennium. We cannot therefore be sure that Xenophon and Arrian were describing to the same hound, particularly when we cannot be certain what the Laconian hound really looked like.[1] Some breeds appear to be as mythical as the heroes after whom they were named such as Xenophon's Castorians[2] (3.1). Most were named after their place of origin and could well be merely similar or the same dogs that came from different locations. Others were

given different names for the same place of origin such as the Laconian/ Lacedaemonian/Spartan hound.

The dog literature

Dogs feature in the very earliest Greek literature such as Homer's famous story of Odysseus' hound Argus who was the only one to recognise his master on his unexpected return to Ithaca[3] and thereafter in many different ways: as hunting hounds (e.g. Ovid *Metamorphoses*[4]), as guard-dogs (e.g. Aristophanes *Lysistrata*[5]) and as pets (e.g. Martial, see below p. 93). But in addition to these causal references to dogs, the Graeco-Roman world is rich in literature written specifically about dogs. They feature in encyclopaedic works such as Aristotle's *History of Animals*, the *Natural Histories* of Pliny and Aelian and Pollux *Onomasticon*. Aristotle goes into some detail on such matters as reproduction and breeding. Pliny praises dogs' fidelity and intelligence, and describes their breeding and ailments.[6] Pollux has a detailed section on hunting which is copied largely from Xenophon but adds significant detail.[7]

It is from hunting literature that we have the most information. For hunting must have been amongst the first reasons for domesticating dogs (see Chapter II). Hunting has always been seen by the military caste as an important recreation that taught many of the skills which would be needed in warfare; something emphasised by Xenophon in his treatise *On Hunting*. For this reason perhaps more books on hunting have survived than any other writing about dogs. The earliest of these is Xenophon's, written around 390 B.C., it is a short book of 13 chapters in which he describes all aspects of hunting with dogs: the equipment needed, the breeding of hounds, their training and how to hunt the different game. The next work in chronological order is Grattius' *On Hunting*, a poem in Latin written around A.D. 8 of which some 540 lines have survived. The second century A.D. produced Arrian's *On Hunting* which was ostensibly written as a commentary on Xenophon, but contains much original material about hunting and hounds. The surviving examples of the genre then continue with Oppian's *On Hunting*, which adds little new to the dog literature and the final surviving work is Nemesianus' *On Hunting* which unfortunately is missing the part which must have described the actual hunt.[8]

In addition to the hunting literature, there are two further works that give us more information about dogs. These are the two long treatises *On Agriculture* by Varro and by Columella in which guard/shepherd-dogs are discussed.

Classical Breeds

Oppian says that "The Breeds are without number"[9] and Grattius, "Dogs belong to a thousand lands".[10]

Given the caveat about breeds above, classical dog literature mentions some fifty breeds which is a remarkably large number when one thinks of the four or five that we can identify from ancient Egypt or Mesopotamia. The table in the appendix lists all those 'breeds' mentioned in the canine literature which probably include all the main types. The list has a very wide geographical spread from Britain in the west to Tibet (?) or India in the east and from the Ukraine in the north to Egypt in the south. This increase in the number of breeds of dog described in the literature, clearly reflects the geographical expansion of the classical world from the time of Xenophon to its maximum extent under imperial Rome. Naturally the majority of breeds come from Greece and Italy. Our difficulties really begin when we try to identify these breeds in the pictures of dogs that we see in classical art.

5.5 'Maltese' dog from a Greek vase from Vulci in Etruria, Italy.

This growth in the number of identifiable breeds throughout the classical period is supported by archaeology. In pre-Roman Britain for instance the dogs appear to have been reasonably uniform in size[11] but after the Roman invasion of 43 A.D. dog bones of a much larger span of sizes are found from animals as small as terriers to some as large as today's large breeds 23–70 cms (9"–28").[12] This is also true of other parts of the Empire so that as S.J. Crockford says "... the Roman contribution to the creation of numerous physically distinct dog breeds is undeniable."[13]

Dogs in art

Pictures principally on vases, in wall paintings and mosaics show a large number of different dogs, but unfortunately we have only one which is labelled. This is a dog on a Greek vase where it is called a Melitean (fig. 5.5). Thus though it is reasonable to assume that the prick-eared, snipe-faced hound of medium size was the Laconian (figs 5.7, 8), or that the heavier mastiff type is the one called Molossian[14] in the literature (figs 5.1, 14), we have no means of being certain.

The earliest depictions of dogs in our period are on Greek vases. From around the seventh century B.C., they become sufficiently detailed for us to be able to talk sensibly about the hounds they portray. The early vases from the archaic period show large hounds, often with distinctly shaggy necks such as those in the Calydonian boar hunt, fig. 5.6. These appear to be used for hunting all game: boar, deer or hares. Later vases from the classical period in the fifth century B.C. appear to show two main types of hound: the sleek smooth-haired hound used for hunting deer and hares and the stockier more rough-haired hound used for boar. It seems reasonable to assume that these correspond to the two main types which are most commonly mentioned: the Laconian being the former and the Molossian the latter.

5.6 Two hounds of the Calydonian boar hunt with shaggy necks and tails, detail from a vase of the sixth century B.C.

In addition to the vase paintings we have both frescoes and mosaics. With the larger scale of these works, we get a better idea of size and conformation. As well as hunting dogs we also have guard-dogs and household pets. Mosaics of mythological and hunting scenes become common by the second century A.D. They appear all over the Roman world but are particularly fine in Sicily and North Africa. From Tunisia for instance, the mosaics which decorated the floors of the great villas show scenes of hunting and of the agricultural year and many dogs are included. The finest paintings come not unexpectedly from Pompeii

V: DOGS OF THE CLASSICAL WORLD 87

which has, in addition, the famous 'cave canem' ('beware of the dog') mosaics (fig. 5.9) and even casts of actual dogs (fig. 5.10).

There are as many sculptures of dogs as there are paintings or mosaics. Amongst the finest Roman period sculptures are the twin pairs of hounds from Italy.[15] Carved from white marble, they show two hounds, similar to our whippets in a tender scene. Also in the British Museum is the 'Dog of Alcibiades' which is a Roman period copy of a Greek original and is a massive 'Molossian' hound (fig. 5.1).[16] Other fine statues include the bronze fountain from Pompeii of boar hounds attacking a fierce boar.[17] Hounds appear on sarcophagi which frequently have hunting scenes. Other sculptures of dogs can be seen on stelae such as the little lap-dog which accompanies its mistress in the stela of Pompeia which is typical of the genre (5.12).

We therefore have a mass of evidence, pictorial and literary, from which we can trace the development of the domestic dog into and during the classical period. While we cannot be certain of all the details, the outline is clear.

Principal Types Of Dogs

As is emphasised in the chapter on Egyptian dogs (p. 39), in one's search for breeds, one should not lose sight of the humble mongrel. Arrian may talk of his pampered and aristocratic hounds, Columella of the utility of his fierce guard dogs, but just as today throughout southern Europe, the Middle East and North Africa by far the most numerous dogs must have been humble pariahs.

Hunting dogs

Classical hunting literature begins as we have seen with Xenophon. He hunted on foot and used scent-hounds to drive hares into nets which he describes in some detail while listing the equipment and establishment needed.[18] He says that you should have hounds with good noses and sound conformation and after listing the faults gives us a 'breed standard'[19] by which to judge them: "First then they should be large, and have quick-moving, snub-nosed, well-knit heads, having the lower parts of their foreheads sinewy, prominent, black, lustrous eyes, broad foreheads with a pronounced central furrow, small, thin ears, hairless at the back, long, supple, rounded necks, broad chests, quite plump, with the shoulder-blades a little detached from the shoulders, front legs small, straight, round, firm, elbows straight, ribs not set pointing to the ground, but running crosswise, loins fleshy, of average size, neither too supple nor too stiff, the flank moderate in

5.7: (left) A hound of the Laconian type from an Athenian vase of a hare hunt, 5th century B.C.
5.8: (right) A similar hound in a mosaic from La Chebba, Tunisia, 2nd century A.D.

length, hind quarters round, plump at the back, not tight on top, but with the inner part tucked inside, the part below the belly hollow, as also the belly itself, long, straight, lashing tails, the upper thighs hard, the lower thighs long, rounded, firm, the hind legs much bigger than the front and bent, the feet round. If the hounds are like that, they will be strong in appearance, agile, well proportioned, fast, with an alert look and a good mouth."[20] After describing the hare and how to hunt it, Xenophon goes into some detail on breeding and training, "Towards the end of this time, so that they may the more quickly be impregnated, they should be put to good quality dogs; and when they are carrying young, do not take them hunting all the time, but only occasionally, for fear they miscarry through too much effort. Their period of gestation is sixty days."[21] In addition to the hare which takes up over 70% of his book, he also hunts deer and wild boar. The technique he uses is very similar to his hare hunting but with presumably larger (Indian) hounds and stronger nets. Like most huntsmen he is very dogmatic. He, if one leaves out the mythical Castorian and Vulpine hounds, only mentions Cretan, Indian, Laconian and Locrian hounds and all of these, with the exception of the Laconian, only for hunting deer and wild boar. But his Roman successor, Grattius, writing some four hundred years later, mentions some 22 'breeds'. Amongst these is the *vertragus*[22] (a Celtic hound) which was a sight-hound as Arrian makes clear which results in a very different hunting technique and one which Arrian boasts was much more successful, "And that he did not know either of any other breed of hound which could have been similar in speed to the Celtic can be shown by the following: he says that those hares that are caught by hounds are caught contrary to their natural physique or by accident. But if he had

known of Celtic hounds, I think he would have said this very thing about the hounds, that if hounds do not catch hares by speed, their not catching them is contrary to their natural physique or accidental. For a hare could never get away from those that are well built and spirited unless some difficult ground got in the way, or a wood hid her, or a deep hollow in the earth removed her, or a ditch let her run across in unseen ground."[23]

Sight-hounds were fast enough to catch hares on their own and the huntsman is freed from the use of fixed nets. He could hunt on foot or from horseback. Essentially Arrian advocates the release of a pair of hounds which would course the hare until it was either caught or got away. For this he needed hounds which "... must stand long from head to tail; in considering every type of dog, you could not find any single mark of speed and breeding as accurate as the length of the body, and conversely shortness of body indicates slowness and poor quality. So much so that I have often seen dogs with many other defects, but, because they happened to be long, they were quick and spirited. ... The hounds should have large, soft, ears, so that through their size and softness they may appear to be folded; that is best. All the same there is nothing wrong with their being straight, provided they are not small and hard. The neck should be long and round and supple, so that if you pull the hounds back by the collar the neck seems to be bent double because of its suppleness and softness. Broad chests are better than narrow, and the hounds should have their shoulder-blades well separated and not joined together, but moving as freely as possible. The legs should be rounded, straight, firm, the sides elegant, the loins broad and strong, not fleshy but sinewy, the flanks relaxed, the croup not tight together, the belly hollow, the tail thin and long, with thick hair, soft and flexible, the end of the tail rather hairy, the lower thigh long and firm."[24]

In the Roman period we have depictions of these hounds which stand "long from head to tail", particularly from North Africa and the Middle East and especially from Tunisia (see figs 5.2-3). These are clearly closely related to the Arab's coursing hounds the Saluki/sloughi which we have already met in Ancient Egypt and the Middle East. But here we have a problem as Arrian clearly states that his coursing hound, a *vertragus*, was a Celtic hound from Europe and not oriental.[25] This becomes even odder when one considers that both Xenophon and Arrian had extensive experience in the Middle East, the first as a general in Asia Minor and the second as the Roman governor of Cappadocia in modern Anatolia, where with their enthusiasm for hunting, they should have seen Salukis. This is particularly surprising as the Saluki is the only breed that we trace with any degree of certainty from antiquity to the present day.

From these descriptions and the representations we do however get a reasonably clear picture of classical hunting hounds. The archaic Greek vases appear to show 'general purpose' hounds: reasonably large, somewhat heavily built and used in conjunction with nets against all kinds of game. From the fifth century B.C. there seems to be more specialisation with sleeker scent-hounds of the Laconian type used for hare hunting and heavier more shaggy ones of the Molossian type for hunting big game such as boar. By Roman times, with the expansion of the empire, came an increase of the number of breeds; hounds became even more specialised and include very sleek and fast coursing hounds of the *vertragus* type.

Guard and shepherd dogs

5.9: A 'cave canem' mosaic from Pompeii, before A.D. 79, of a dog guarding the entrance hall of a house.

Of the three substantial surviving treatises on agriculture, the earliest Cato (c.160 B.C.) merely says of guard/shepherd dogs that they should be "chained during the day, so that they are keener and more watchful at night".[26] But both Columella and Varro have left us much more detailed information.

Varro, writing around 37 B.C., gives a 'breed standard' for a guard/shepherd dog "They should be comely in face, of good size, with eyes either darkish or yellowish, symmetrical nostrils, lips blackish or reddish, the upper lip neither raised too high nor drooping low, stubby jaw with two fangs projecting somewhat

from it on the right and left, the upper straight rather than curved, their sharp teeth covered by lip, large head, large and drooping ears, thick shoulders and neck, the thighs and shanks long, legs straight and bowed rather in than out, large, wide paws which spread as he walks, the toes separated, the claws hard and curving, the sole of the foot not horny or too hard, but rather spongy, as it were and soft; with the body tapering at the top of the thigh, the backbone neither projecting nor swayed, tail thick; with a deep bark, wide gape, preferably white in colour, so that they may the more readily be distinguished in the dark; and of a leonine appearance."[27]

Columella, in the first century A.D. is very much in agreement with Varro saying that every farmer needs dogs to guard both his property and his flocks. Interestingly in his long textbook on farming he does not talk about dogs being used to round up and control the flocks as our modern shepherd dogs do; the role of the shepherd dog was guarding against wild beasts, particularly wolves. "... There are three different reasons for procuring and keeping a dog. One type of dog is chosen to oppose the plots of human beings and watches over the farm and all its appurtenances; a second kind for repelling the attacks of men and wild beasts and keeping an eye at home in the stables and abroad on the flocks as they feed; the third kind is acquired for the purposes of the chase, and not only does not help the farmer but actually lures him away from his work and makes him lazy about it."[28]

Like Varro, Columella stresses that the guard dog should be strongly built "amplissimus corporis"[29] and black because this colour is more intimidating in the daylight and at night blends in with the dark. Its size is emphasised as it should be "squarely built ... and it should have a head so large as to form the largest part of it".[30] It should be shaggy and have a short tail; he even gives instructions for docking the tails of his dogs. From this description it appears to be rather like the boar hounds which we have seen above or perhaps not unlike a Newfoundland in appearance.

Both authors say that the shepherd dog however should be white (cf. fig. 4.10), while Columella explains that this makes it distinguishable to the shepherd from a raiding wolf. From this it is clear that the dogs are at least as large as wolves otherwise they could not be mistaken for one. Columella however distinguishes the guard dog and the shepherd dog saying that the latter should be less heavily built than the guard dog because it needs to be fast enough to run the wolves off or recapture animals already taken "... since he has to repel the stealthy lurking of the wolf and to follow the wild beast as he escapes with his prey and make him drop it and to bring it back again. Therefore a dog rather long, slim build is better ..."[31]

5.10 Guard/shepherd dog, Oudna, Tunisia.

It should perhaps be noted, that while many breed names are given for hunting dogs and while one can assume that guard-dogs were of the type we understand to be Molossian, none of the authors above mention a particular breed as being suited to be guard-dogs.

5.11 Cast of a guard-dog which died in the eruption of Vesuvius in A.D. 79.

The guard dogs from Pompeii, whose destruction in 79 A.D. falls between the books of Varro and Columella, do not seem to be as large as the guard-dogs being described above. They are lighter in build and not unlike our modern Collie, (figs 5.9, 5.11). The height of the Pompeian hound above is 19" (48cms)[32] which would indeed make it the same size as a Border Collie. The size of their kennels of which several survive, confirms this. The reason is perhaps because they are guarding town houses and Columella's dogs country estates. A North African farm dog, on a chain and in front of its kennel, very much like what one imagines their descriptions would look like, can be seen in a mosaic from Carthage (fig. 5.12).

5.12 A guard-dog chained to its kennel in a mosaic from Carthage, 4th–5th century A.D.

Pet Dogs

Dogs have been used as man's companion from early times. The Egyptian dogs in figs 3.12-13 seem too small for guarding or hunting and date from the second millennium B.C. The value of the small animal as a companion is even confirmed by modern medicine which has evidence that those with such pets are much less liable to heart disease. In the classical period pet dogs do indeed appear in literature; Martial's is a good example:

> Issa's more worthless than Catullus' sparrow,
> Issa's purer than the kiss of a dove,
> Issa's more charming than all the girls,
> Issa's dearer than the gems of India.
> Issa's Publius darling puppy.
> If she whines, you will think that she is speaking,
> She feels his sorrow and joy.
> Lying upon his neck she sleeps,
> Without seeming to breathe at all.
> And when nature calls,
> She never leaves a drop on the bedspread,
> But with a tap of her paw she wakes him,
> And shows that she wants to be put down from the bed
> And she asks to be picked up again.
> Such is the modesty of this chaste little dog
> That she does not know love, nor have we found
> A mate worthy of this tender girl.
> So that death will not take away Issa.
> Publius had a picture painted of her
> In which you will see such a likeness of her
> That Issa herself is not more like her.
> Place Issa and the picture together,
> And you will think that you see two Issas,
> Or that both are pictures.[33]

The literature however does not have a 'breed standard' for a pet dog as we have for both hunting and guard dogs, so we have little information about their appearance and temperament. But one 'breed' which we can recognise is the Melitean. Aristotle describes it as similar in size to a marten "about the size of the small kind of Melitean miniature dog".[34] This must have been a well-known breed because it is also mentioned by Pliny[35] and Strabo.[36] It can be seen in fig. 5.5.[37] We do have pictures of pet dogs from Pompeii which appear to be not unlike terriers or even the Maltese and it seems reasonable to assume that this was the kind of small lap-dog Martial is talking about. While hunting and guard/shepherd dogs were bred for a specific purpose and needed a temperament and conformation to suit that purpose, pet dogs were simply any that caught one's fancy.

5.13 A pet dog mourns its mistress, Pompeia Margaris, 1st–2nd century A.D.

Other uses of the dog

In war

Dogs are reported to have been used in war (see p. 48 and fig. 4.9). Pliny states for example says that "The King of the Garamantes [an African tribe] was escorted back from exile by two hundred dogs who did battle with those that offered resistance. The people of Colophon and also those of Castabulum had troops of dogs for their wars; these fought fiercely in the front rank, never refusing battle, and were their most loyal supporters, never requiring pay".[38] One tends to be sceptical about the value of dogs in warfare despite the references to this in classical literature.[39] It is difficult to imagine that dogs, however large and fierce, would be effective attacking armed and armoured infantry. In Egypt for example one can see Tutankhamun's Salukis under his chariot killing his enemies, an event which would seem more symbolic than a record of an actual

event.[40] In the same way one is sceptical of the ability of Ashurbanipal's mastiffs to attack lion, or Pollux story that Peritas, Alexander's dog, was famous for fighting lion.[41] Large cats are much too heavily armed to be attacked by dogs and indeed in Africa dogs are amongst the favourite prey of leopards.

As food?
Though earlier man may have eaten dogs as part of their diet, it seems unlikely that the Greeks or Romans ever used dogs as food. There is a line in Aristophanes *Knights* (1398) where sausages were said to made from a mixture of the flesh of dogs and asses but this was no doubt an insult rather than a statement of fact.

Care of the dog
Having looked at the different breeds and types of dogs and the difficulty of marrying the descriptions to the representations, we come onto firmer ground when we look at their care and management. We have a great deal of practical advice, most of which is just as valid today. We have 'breed standards' by which a good hound should be judged as for example Xenophon's and Varro's above. There is much advice given about breeding and about cross breeding. Most other aspects of dog care are also described.

Breeding
While there are obvious flights of fancy about the breeding of dogs, such as Aristotle's belief that dogs and tigers could cross-breed to produce Indian hounds,[42] most of the information given by those authors who were practical farmers or huntsmen is sound. They were well aware of the need for care of the bitch and for careful selection of the dog. They correctly state that a bitch when she comes into season should be mated at around a fortnight and that pregnancy lasts about sixty days.[43] All agree that young dogs especially those under a year should not be allowed to mate.[44] Curiously none of the ancient authors describe the relationship between the dog and the bitch and whether one should breed from related or unrelated dogs. Cross-breeding was commonly practiced for a specific purpose. Thus Grattius for instance goes into some detail on how the best hounds are cross-bred to produce the most desirable characteristics. "I shall cross the advantages of different breeds: one day an Umbrian mother will give to the unskilled Gallic pups a smart disposition; puppies of a Gelonian mother have drawn spirit from a Hyrcanian sire: and Calydonia [ie Aetolia] good only at pointless barking will lose the defect when improved by a sire from Molossis. In truth, the offspring cull the best from all the excellence of the parents, and kindly nature attends them."[45] If his favourite breed, a *Metagon* is truly named after its cross-breeding,[46] then "couple well-matched mates and mark the offspring with

the pledge of their pedigree, letting the parents who produce this wonderful progeny in the vigour of their youth yield you a fine *metagon*".[47]

Rearing and training puppies

Advice on rearing of puppies is plentiful and one can quarrel with little of it. Grattius for example says when choosing a puppy you should " ... then look for the [pup] that already has vigour, impatient of equality with the rest, has raised him above them: he aims at sovereignty beneath his mother's belly keeps her teats wholly to himself, his back unencumbered and unpressed by the others so long as the genial warmth of the heavens is kind to earth (during the sunny day), but when evening has shrivelled him with chilliness his bad temper flags and this strong pup lets himself be snugly covered by the sluggish crowd (of the rest). It must be your care thoroughly to weigh his promised strength in your hands; he will humble his light brothers with his weight."[48] The only real oddity is Arrian's idea that puppies should be suckled by pedigree bitches only and not by common-born 'wet-nurses'[49] and then weaned (rather late) onto solid foods.[50]

Little or nothing is said about basic obedience training, but training for hunting should begin at eight months for bitches and ten for dogs according to Xenophon, while Arrian says that hunting training should begin at ten months for a bitch but that a dog should be two years old. Pollux would have one take out a puppy bitch at six months and a puppy dog at eight but on a long lead.

The training recommended for guard dogs by Columella is rather different. "Puppies should not be allowed to run loose during the first six months until they are grown strong, except to join their mother in sport and play; later they should be kept on the chain during the day and let loose at night."[51] They should also not stray from the farm and its outbuildings.[52] He does not talk about specific training for shepherd dogs

Feeding

Little is said about how often dogs should be fed. One assumes that this would have been because it would have been the job of a kennel-man who would no doubt have been a slave. But there is a lot on the actual food, particularly for puppies with an emphasis on cereals: Columella recommends "barley flour with whey ... or bread made from the flour of emmer or bread-wheat mixed with the liquid of boiled beans".[53] Arrian says "Those that are not choosy about their food, but enjoy bread made of wheat or barley, are good. For this is the best food for a hound. And there is no worry that it will fill itself too full of it. It is also better if they enjoy their food dry. But if you steep it in water, and they like that, there is no harm. If a hound has been sick, either add gravy from fat meat or

roast ox-liver in hot ashes, then grate it and scatter it over the food like barley-groats. And this is good for puppies to add strength to their limbs when they come off milk; but milk is best for the growing puppy up to the ninth month and beyond, and if it has been sick and is delicate both drink and food are good. But fasting is good while it is sick."[54] Varro recommends that "they eat scraps of meat and bones ... you should also feed them barley bread, but not without soaking it in milk ... they are also fed on bone soup and even broken bones as well; for these make their teeth stronger and their mouths of wider stretch ...".[55] Nemesianus says that puppies should be weaned with "whey and on bread with milk."[56] Grattius similarly advocates "milk and simple pap: they must not know other luxuries and the other outlays of a gluttonous life".[57]

The treatment of diseases

Classical authors were familiar with the main diseases to which dogs are subject: mange, rabies, distemper and hard-pad. Until modern times there were of course no real cures for these though in the case of the former, some alleviation seems possible. There is much advice about praying to the appropriate deity, usually Artemis/Diana but also some practical remedies.

Mange

For this unpleasant and distressing condition Arrian advocates that one's hounds sleep with a human which one would have thought slightly uncomfortable for the latter and even dangerous as it is contagious "... a man sleeping beside a dog removes discomfort from its skin, but dogs sleeping in the same place increase any skin defects by contact and heat. Consequently they generally become mangy, when they take their rest in the same place.".[58] Columella is altogether more practical "gypsum and sesame should be ground together in equal portions and mixed with liquid pitch and smeared on the part affected; this remedy is reported to be suitable also for human beings. If this plague has become violent, it is got rid of by the juice of the juniper."[59] Grattius like his contemporary Columella used "doses of bitumen mixed with fragrant wine and portions of Bruttian pitch and ointment from the unregarded dregs of olive oil",[60] if the disease were caught early enough. He also recommends bathing the dog in the sea. If this fails then you must destroy the mangy dog to prevent the disease spreading to rest of the pack. Nemesianus would have us "... blend tart draughts of wine with Minerva's olive-fruit ...".[61]

Rabies

This scourge seems to have been treated rather lightly for so dangerous a disease for dog and man. Indeed both Aristotle and Pollux seem to have believed the rabies could not be passed on to man at all: "Of these rabies produces madness,

and when rabies develops in all animals that the dog has bitten, except man, it kills them and this disease kills the dog as well."[62] Grattius thought that rabies was caused by a worm that "steals in where the tongue is rooted its firm ligaments" and claimed that it can quickly be cured by cutting out this worm.[63] Another author who treats rabies in man surprisingly lightly is Pollux " ... rabies is difficult to cure; but distemper leads to death. Everything bitten by a dog affected with rabies dies, and man alone survives."[64] Pliny thought it only dangerous in one month: "Rabies in dogs, as we have said, is dangerous to human beings in periods when the dog-star (Sirius) is shining, as it causes fatal hydrophobia to those bitten in those circumstances". He repeats Columella's belief that docking the tail was a prophylactic against rabies.[65] Nemesianus used "... the fetid drug got from the beaver and work it well, forcing it to grow viscous with the friction from a flint: to this should be added powder from pounded or chopped ivory and by a long process of blending you will get both to harden together: next put in gradually the liquid flow of milk besides, to enable you to pour in through an inserted horn doses which do not stick in the throat ...".[66] One wonders in the circumstances how many people died a terrible death from hydrophobia.

Distemper and hard-pad

The passage quoted above from Pollux begins with "But arthritic foot is not wholly curable; rabies is difficult to cure; but distemper leads to death." By arthritic foot, one assumes that he means hard-pad. Aristotle says that "Dogs suffer from three diseases: these are called rabies, dog-strangles and foot-ill ... The strangles too destroys the dogs; and only few survive after the foot-ill."[67] One assumes that foot-ill is also hard-pad.

Other illnesses

Aristotle warns against ticks "The 'dog-wreckers' as they are called are found on dogs".[68] One other remedy comes from Grattius for what one assumes was tetanus: "What plague is sharper that 'robor' or what path nearer to death? But still for it there comes here assistance more active than the powerful anger of the first ailment. Yet if a lost opportunity baffles first aid, then you must attack the furious pestilence when prospects are likeliest; sudden disturbances calls for sudden relief. The nostrils must be cut slightly with steel as well as the two muscles of the shoulders and blood is to be drawn from both ears: from the blood comes corruption, from the blood the violence of the insatiable plague ... and you must sprinkle the wounds with the sediment of oil-dregs and Massic wine ...".[69] Cutting the nostrils might even help the unfortunate dog breathe, but the other parts of the remedy seems likely to do more damage than good!

V: DOGS OF THE CLASSICAL WORLD

Equipment for dogs

5.14 A bundle of leads in a mosaic from Althiburos, Tunisia, late 3rd century A.D.

As one would expect, most authors give advice on the equipment needed: Xenophon for a hunt says that "Accessories for the hounds are collars, leads and belts: the collars should be soft and wide, so that they do hurt the coats of the hounds".[70] Varro for a guard dog says "collars are placed on them – the so called *melium*, that is a belt around the neck made of stout leather with nails having heads; under the nail heads there is sewed a piece of soft leather, to prevent the hard iron from injuring the neck."[71] Collars and leads need little comment, but the body belt is more interesting as it is not used today. Essentially, according to Pollux, it was a broad belt onto which were sewn spikes in a similar manner, one assumes, to Varro's collar spikes (figs 4.15, 5.14). This belt was to protect the flanks of the hound, particularly boar-hounds, against injury. They could also be used on a bitch to prevent mating.[72]

Kennels are only mentioned in any detail by Arrian. He, somewhat eccentrically, recommends that one should sleep with ones hounds as "There is nothing like a

5.15 A hound chasing a boar into a net, detail from a mosaic from Carthage, 2nd century A.D. It is wearing a body belt to protect its flanks and a collar with a loop or ring.

soft warm bed, the best being with a man, because thus they become fond of humans, and they find pleasure in human skin, and feel no less affection for the one they sleep beside than for the one who gives them food." In kennels they tend to spread diseases amongst themselves. He goes on to describe how he gives his hounds a massage which they greatly enjoy "Rubbing down the whole body is also a great benefit to a hound, no less than to a horse; for it is good for making the limbs firm and strong, and it make the coat soft and the skin colour bright. And it removes any skin defects. Massage the back and the loin with the right hand, putting the left under the flank, to prevent the hound from suffering discomfort by being pressed down from above as she squats. Stroke the sides with both hands, and from the croup down to the ends of the feet, and the shoulder-blades in the same way. When the massage seems to be sufficient, raise her up, taking hold of the tail and stretching it out, and let her go; and she will shake herself as she is let go, and will show clearly that she enjoyed the treatment."[73] Such matters in the levels of society for which the literature was intended were presumably dealt with by servants and hence required little comment.

Greek and Roman attitudes to dogs

Hunting men such as Arrian were clearly very fond of their dogs. Arrian for example has left us with a most moving picture of his favourite hound which is worth quoting in full: "For I myself reared a hound with the greyest of grey eyes, and she was fast and a hard worker and spirited and agile, so that when she was young she once dealt with four hares in a day. And apart from that she is most gentle (I still had her when I was writing this) and most fond of humans, and never previously did any other dog long to be with me and my fellow-huntsman Megillus as she does. For since she was retired from the chase, she never leaves us, or at least one of us. If I am indoors she stays with me, and accompanies me if I go out anywhere; she escorts me to the gymnasium, and sits by while I am exercising, and goes in front as I return, frequently turning round as if to check that I have not left the road somewhere; when she sees I am there she smiles and goes on again in front. But if I go off to some public business, she stays with my friend, and behaves in the same way to him. If one of us is ill, she does not leave him. If she sees us even after a short period of time, she jumps up in the air gently, as if welcoming him, and she gives a bark with the welcome, showing her affection. When she is with one of us at dinner she touches him with her paws alternately, reminding him that she too should be given some of the food. And indeed she makes many different noises, more than any other dog that I think I have seen; and she shows audibly what she wants. And because when she was being trained as a puppy she was punished with a whip, if anyone even to this day should mention a whip, she goes up to the one who has said it and crouches down

like one beseeching, and fits her mouth to his mouth as if she is kissing, and jumps up and hangs from his neck, and does not let him go until the angry one gives up the threat. And so I think that I should not hesitate to write down the name of this dog, for it to survive her even in the future, viz. that Xenophon the Athenian had a dog called Hormé, very fast and very clever and quite out of this world."[74] One aspect of their regard for dogs was the importance that they gave to names.

Oppian says "To the puppies give names that are short and swiftly spoken that they may hear a command swiftly."[75] Xenophon says that they should be of two syllables and gives a list: "Give them short names, so that it will be easy to call them. They should be such as Spirit, Courage, Handle, Spike, Lancer"[76] Arrian agrees with this saying that Xenophon's are "Well chosen".[77] Columella's list of suitable names for guard-dogs is very similar and again of two syllables in the original language and mixed Latin and Greek: Puppy-dog, Fierce, Laconian, Swift, Zealous It is perhaps interesting that though Xenophon is talking of hunting hounds and Columella of guard-dogs, that they still used the same or similar names for their dogs. Perhaps our habit of giving dogs popular names such as Rover is the same. On Greek vases hounds are also named such as those on the Calydonian boar hound in fig 5.6 whose names are given as Ormenos and Methepon. For Roman hounds we have two excellent names for Salukis from Tunisia: *ederatus* (ivy-leaf) for a brindled dog and *mustela* (weasel) (fig. 4.1).

Clearly there were many other dogs that were highly regarded as the poem about Issa, quoted above, shows. One would be very hard pressed to find so much affection and importance given to cats, despite their usefulness.

But not all references to dogs are complimentary. The Greek school of philosophy, the cynics (cynos = dog), were so called because they were proverbially shameless and vicious. Even Martial for all his praise of Issa is quite happy to satirise his enemy as a dog.[78] Indeed from early times the dog was a symbol of degradation as well as of nobility and faithfulness.

In all essentials the Greek and Roman attitude to dogs is very similar to our own whether they were Arrian's aristocratic hound or Martial's pet. They did not deify canines like the Egyptians and although lacking our veterinary medicine, one can quarrel with little in their treatment of their dogs.

* * *

During the classical period we see the number of breeds multiplying from the half dozen mentioned by Xenophon to the fifty or so found in later authors. At the same time they increase in specialisation and in range of size. The earlier Greek hounds used for hunting smaller game all appear to be scent-hounds of the Laconian type while the later Roman ones also included sight-hounds of the Saluki type. Guard dogs too range from large dogs of the Molossian type, similar to those used for hunting larger game such as boar and deer, to smaller kinds such as the Pompeiian 'Collies'. Indeed they appear very similar to the dogs of own day. This is not too surprising as dogs performed the same tasks then as they do now, excluding, of course our large class of gun-dogs. If they performed well, they were bred from and this established the breed. Today we are sadly seeing breeds deteriorate because they are not used for their original functions. We even have evidence that the Romans had pet breeds, the Miletean, though no doubt most ancient pet dogs varied as much as ours do and were of indeterminate breeding.

The pattern of the development of the dog during our period is borne out by the literature, the representations and by archaeology. The wolf had already travelled a long way from its wild ancestors by classical times. But how many Graeco-Roman breeds are ancestors of those with which we are familiar is very much a matter of conjecture. If it looks like a Saluki and behaves like a Saluki, it seems to reasonable to assume that it is a Saluki. But one hopes that the day is not too distant when biologists will be able to determine from examining DNA if this is correct. Then we should really be able to say how much our modern breeds owe to those of Greece and Rome.

V: DOGS OF THE CLASSICAL WORLD

List of Classical 'breeds'

This list is not exhaustive as it excludes most references to the wider literature, except where noted – Xen. = Xenophon On Hunting; Arist. = Aristotle History of Animals; Gra. = Grattius On Hunting; Arr. = Arrian On Hunting; Plin. = Pliny Natural History; Poll. = Pollux Onomasticon V; Opp. = Oppian On Hunting; Nem. = Nemesianus On Hunting

Acarnarian see also Calydonian, Gra. 183–5, 'marvellously quick, marvellously efficient in scent', for boar
Aetolian, Gra 186–92
Agassian *see British*
Amorgian, Opp. 1.374
Arcadian (see also Lycaonian), Poll. 37, Opp. 1.372, 1.394
Argive, Poll. 37, Opp. 1.372
Athamanian, Gra. 182, compared to a Molossian
Ausonian, see also Umbrian, Poll. 1.371
Azorian, Gra 183
British, Gra. 174-199 'magnificent but ugly', Opp. 1.468-80, Nem. 225 'swift, know as Agassian'
Calydonian, *see Aetolian*
Carian, Arr. 3.1-2 'follow the line', Poll. 37, Opp. 1.371, 1.395
Castorian, Xen. 3.1, Poll. 37 bred by Castor, crossed with Vulpine
Celtic see also *Vertragus*, Gra. 'great glory exalts the far-distant Celtic dogs', Arr. 3.1-6 also called Segusian 'one could not write anything worth reading', Poll. 37, Opp.1.373
Chaonian, Poll. 39
Chinese *see Tibetan*
Cretan, Xen. 10.1, Gra. 212, Arr. 3.1-2, Poll. 37, 5.40–1, Opp. 1.373, 395, *also in* Ovid Meta. 3.208, Aelian *NA* 3.2 etc
Egyptian, Plin. 8.148, Opp.1.374
Elean, Opp. 1.394
Elymaean, Poll. 37
Epirote Varro 2.9.5
Eretrean, Poll. 37, 40
Gallic, Gra. 194 'unskilled' *c.f. Celtic*, Plin. 8.248† †Gauls cross hounds with wolves
Gelonian, Gra. 157 'cowardly but clever'
Glympic, Gra. 214 *see also Laconian*
Harmodian, Gra. 37 named after the hero
Hyrcanian, Gra. 161 'fierce and savage', Poll. 37, 38† †dog x lion, also Aelian *NA* 7.38
Iberian, Poll. 37, Opp. 1.371, Nem. 228
Indian, Xen. 9.1, 10,1 'strong, large fast, spirited', Arist. 607a4 †'come from tiger and dog'†, Plin. 8.149, Poll. 37, 38, 42-4,

Laconian, also Spartan, Lacedaemonian, Xen. 10.1, Arist. 574a16 ff, Gra. 212, Arr. 3.6, Poll. 37, 38, Opp. 1.372, 396, Nem. 107, 224, *also in* Varro 2.9.5, Soph. *Aj.* 'keen scented course of some Laconian bitch', Ovid Meta 3.208, 223 etc
Libyan, Poll. 37, Opp. 1.375, Nem. 229,
Locrian, Xen. 10.1
Lycaonian, Gra. 160 big and good temprament
Magnesian *see also Carian*, Poll. 46-7, Opp. 1.374
Median, Gra. 155 'undisciplined but a great fighter'
Menelaids, Opp. 37 named after Menelaus
Metagon, Gra. 209f
Miletean, Arist. 612b10
Molossian, Arist. 608a28-31 'no different from those elsewhere for hunting, but for shepherding it is superior because of its size and courage in facing wild animals', Gra. 181 'renowned'. Poll. 37, 39, Opp. 1.375† †'bright-eyed', Nem. 107, 225, *also in* Aelian 3.2.11, Ar. *Thesm*. 416-7, etc.
Paeonian, Poll. 46, Opp. 1.371
Pannonian, Nem. 227,
Persian, Gra. 158 ' wise'
Petronian, Gra. 158
Pheraean, Gra. 183
Psyllic, Poll. 37
Sallentine, Varro 2.9.5
Sauromantian, Opp. 1.373
Segusian, *see Celtic*
Sycambrian, Gra. 202
Tegean, Opp. 1.372
Thessalian, Poll. 47-8
Thracian, Opp. 1.371, 1.396
Tibetan (or Chinese), Gra. 159 'unmangeably fierce'
Tuscan, Opp. 1.396, Nem. 231 'point to where the hare lies hid'
Umbrian, Gra.172 'good scenters but cowardly'
vertragus, Gra. 203-6 'swifter than thought or a winged bird it runs, pressing hard on the beasts it has found, though less likely to find them when they lie hidden', Arr. 3.6f
Vulpine, Xen. 3.1 dog x fox

Notes

1. For example Cartledge, 215, considers that they must have been like our fox-terrier which seems too small for a general purpose hound. The representations would appear to show a medium to large dog of 18–24", cf. the Pompeian guard-dog note 32 below.
2. Xenophon 3.1.
3. Homer *Od.* 17.301–2.
4. For example at 3.206 on the death of Actaeon: "While he was hesitating, he was seen by his dogs; Melampus and keen Ichnobates were the first to give their signal with their bark, Ichnobates was a Cnossian and Melampus of Spartan breed ..."
5. "Only I give notice that you do not approach my door: beware of the dog!" 1213-5 and in *Thesmophoriasuzae* "... they keep close guard on us, putting seals and bars on the doors of the women's quarters, and on top of that they keep Molossian dogs to frighten the wits out of seducers." 414-7.
6. Pliny 8.61.142–7.
7. Pollux 5.17–86.
8. Oppian, if he was the author of the poem was from Cilicia and wrote in the late second century A.D. Nemesianus wrote his poem about A.D. 284 and was from Carthage which makes him contemporary with the many splendid hunting mosaics from North Africa.
9. Oppian 1.400.
10. Grattius 154.
11. Clark 2000, 163.
12. Cram, 171.
13. Crockford, 303
14. From inland Epirus around Dodona pictured on coins, C.M. Kraay, *Archaic and Classical Greek Coins*, London 1976, 129 and illus. 444.
15. Illustrated in Xenophon, cover, fig. 11.
16. This magnificent statue is currently the subject of an appeal for funds to keep it in the Musuem.
17. Xenophon, fig. 8
18. Xenophon §2.
19. A comparative 'breed standard' for classical hunting hounds is given in Phillips, 17.
20. Xenophon 4.1–2.
21. Xenophon 7.2.
22. Grattius 203–6.
23. Arrian 2.2–3.
24. Arrian 4.2, 5.7–9.
25. Arrian 3.6.
26. Cato 124.
27. Varro 2.9.3–4.
28. Columella 7.12.2.
29. Columella 7.12.3.
30. Columella 7.12.7.
31. Columella 7.12.9.
32. The full dimensions of the hound are as far as it is possible to measure them accurately: height to shoulder 19" (48cms), length of body chest to end of end of tail 25" (63cms). Others stand as

high as 25-6". I am indebited to Sr. Guzzo of the Soprintendenza Archeologica di Pompei for these figures. Full information can be found in C. Giordano, G.V. Pelagalli, *Cani e canili nella antica Pompei*, Atti Accademia Pontaniana VII, (1957-58), Napoli 1959 which catalogues and comments upon the numerous scenes which include dogs in Pompeii as well as including an osteological analysis and a section on Pompeian kennels.

33 I am indebted to Richard Warga, Louisiana State University, Baton Rouge for the translation of Martial's *Issa*, and for material on dogs in war and as food.
34 Aristotle 612b.10.
35 "inter quem est Illyricum Melite, unde catulos Melitaeos appellari Callimachus auctor est" 3.26.152. This breed is normally referred to as the Maltese dog, but Pliny makes it clear that he thinks that it came from the other Melite in the Adriatic. It might perhaps be significant that the name of Martial's dog was Issa which is close to the Adriatic Melite.
36 Strabo 6.277.
37 This is on a vase from Vulci dated to about 500 B.C.
38 Pliny 8.61.142-3.
39 Further information can be found in E.S. Forster, 'Dogs in Ancient Warfare', *Greece & Rome* 10 no. 30 (1941) 114-117 and R.M. Cook, Dogs in Battle, Festschrift Andreas Rumpf ed. T. Dohrn [Krefeld 1952] 38-42.
40 N.M. Davis & A.H. Gardiner, *Tutankamun's Painted Box*, Oxford 1962.
41 Pollux 5.42f.
42 Aristotle 607a4.
43 e.g. Xenophon 7.12.
44 e.g. Columella 7.12.11.
45 Grattius 193 ff.
46 The other explanation of the name is that it does not refer to its cross-breeding but to its ability to turn after the hare.
47 Grattius 263-5.
48 Grattius 278-299.
49 Arrian 30.1.
50 Xenophon 7.1, Arrian 30.4.
51 Columella 7.12.12.
52 Columella 7.12.7.
53 *ibid.*
54 Arrian 8.2-3.
55 Varro 2.9.8-10.
56 Nemesianus 152-4.
57 Grattius 307-9.
58 Arrian 9.2.
59 Columella 7.13.2.
60 Grattius 415-7.
61 Nemesianus 199-201.
62 Aristotle 604a4-10.
63 Grattius 384-98.
64 Pollux 5.53.
65 Pliny 8.51.152-3, Columella 7.12.14.

V: THE DOGS OF THE CLASSICAL WORLD

66 Nemesianus 216–222.
67 Aristotle 604a4–10.
68 Aristotle 557a17.
69 Grattius 465.
70 Xenophon 6.1.
71 Varro 2.9.15.
72 Pollux 5.55–6.
73 Arrian 9.1, 10.
74 Arrian 5.1–6.
75 Oppian 1.444–5.
76 Xenophon 7.5.
77 Arrian 31.2.
78 Martial *Ep.* 5.60.

Bibliography and Abbreviations

Ahsan	M.M. Ahsan, *Social Life under the Abbasids*, London 1979.
Ali	Maulvi Muhammad Ali, *The Holy Qur'an*, Ahmadiyya Anjuman-I-Ishaat-I-Islam, Lahore 1920.
Allen	G.M. Allen, 'Dogs of the American Aborigines', *Bulletin of the Museum of Comparative Zoology, Harvard College* 63 1920.
Anderson	J.K. Anderson, *Hunting in the ancient world*, Berkeley 1985.
Aristotle	*History of Animals*, A.L. Peck, B.M. Balme, eds, Cambridge Mass., 3 vols 1965-91.
Arrian	*On Hunting*, see Phillips.
El-Baghdadi	S. G. El-Baghdadi, 'La Palette décorée de Nubsgat Ezzat', *Archéo-Nil*, 9, 1999.
Bahn	P.G. Bahn, *Pyrenean Prehistory*, Warminster 1984.
Balles	P. Balles, 'The Asil Arabian Saluqi', in *Asil Arabians*, New York, 1993.
Blau	S. Blau & M. Beech, 'One woman and her dog', *Arabian Archaeology and Epigraphy*, 10, 1999.
Blunt	W.F., & A. Blunt, *The Seven Golden Odes of Pagan Arabia*, London 1943.
Boessneck 1977	J. Boessneck *Die Hundeskeletten von Išān Baḥrīyāt (Isin) aus der Zeit um 1000 v. Chr.*, Bayersiche Akademie der Wissenschaften, neue folge, heft 79, München 1977.
Boessneck 1988	J. Boessneck. *Die Tierwelt des Alten Ägypten*. München. 1988.
Breasted	J. Breasted. *Ancient Records of Egypt*, Vol. 1-5. London 1988.
Brewer	D.J. Brewer, D.B. Redford and S. Redford *Domestic plants and animals: the Egyptian origins,* Warminster 1996.
Brunton	G. Brunton, *Mostagedda and the Tasian Culture*, London 1937.
Brunton & Caton-Thompson	G. Brunton & G. Caton-Thompson, *The Badarian Civilisation and Prehistorhic Remains near Badari*, London 1928.
Budge	E.A.W. Budge, *The Gods of the Egyptians*, Vol. II. New York. 1969.
Cartledge	*Xenophon: Hiero the Tyrant and Other Treatises*, London 1997.
Caminos	R. Caminos, *Late Egyptian Miscellanies*, London 1954.
Cato	*On Agriculture*, W.D. Hooper & H.B. Ash (eds), Cambridge Mass., revised ed. 1935.
Chiarelli	A. B. Chiarelli, 'The chromosomes of the canidae', in *The Wild Canids*, M. W. Fox (ed), New York 1975.
Clark 1954	D. Clark, *The Prehistoric Cultures of the Horn of Africa*, Cambridge 1954.
Clark 1995	T. Clark, *The Saluqi in Iraq*, in Goodman.
Clark 2000	K.M. Clark, *Dogged Persistence: the phenomenon of canine skeletal uniformity in British prehistory*, in Crockford.
Clutton-Brock 1989	J. Clutton-Brock, 'A dog and a donkey excavated at Tell Brak', *Iraq* Vol. LI, British School of Archaeology, London 1989.
Clutton-Brock 1993	J. Clutton-Brock, 'Origins of the dog: domestication and early history', *The Domestic Dog: Its Evolution, Behaviour and Interactions with People*. J. Serpell (ed), Cambridge 1993.
Columella	*On Agriculture* H.B. Ash, E.S. Forster & E.H. Heffner, (eds), 3 vols, Cambridge Mass. 1941-55.
Cram	L. Cram, *Varieties of Dog in Roman Britain*, in Crockford.
Crockford	S.J. Crockford (ed.), *Dogs through time: an archaeological perspective*, Oxford 2000.
Dahr	E. Dahr, "Über die Variation der Hirnschale bei Wilden and Zahmen Caniden". *Arkiv für Zoologi*: 32A 1942.

BIBLIOGRAPHY

Darby et al.	W. Darby, P. Ghalioungui, and L. Grivetti. *Food the Gift of Osiris I-II*. London 1977.
Darwin	C. Darwin. *The Variation of Animals and Plans under Domestication*. Vol 1, New York 1868.
Daub	R. Daub, *Windhunde der Welt*, Melsungen, 1979.
Davis 1962	N.M. Davis and A.H. Gardiner, *Tutankhamun's Painted Box*, Oxford 1962.
Davis 1978	S.J.M. Davis & F.R. Valla, 'Evidence for domestication of the dog 12000 years ago in the Natufian of Israel', *Nature*, Vol. 276, 1978.
Debono 1950	F. Debono, "Fouilles: Heliopolis-Trouvailles Prédynastiques", *Chronique d' Égypte* (25), 1950.
Debono 1952	F. Debono. "La Nécropole Prédynastique d' Heliopolis (Fouilles de 1950)". *Annales du Service des Antiquités de l' Égypte* 52, 1952.
Diodorus	*Diodorus Sicilus*, G. P. Gould (ed.), Vol. 1, Cambridge Mass. 1989.
Dobney	K. Dobney, M. Beech, & D. Jaques, *Hunting the broad spectrum revolution: the characteristics of early neolithic animal exploitation at Qermez Dere, northern Mesopotamia, Zooarchaeology of the Pleistocene/Holocene Boundary*, BAR International Series 800, 1999.
Ekvall	R.B. Ekvall, *Role of the Dog in Tibetan Nomadic Society*, Central Asiatic Journal, 8, 1963.
Epstein	H. Epstein, *The Origin of the Domestic Animals of Africa*, New York 1971.
E.I.	*Encyclopaedia of Islam*, E J Brill, Leyden, 1978.
Faulkner	R.O. Faulkner, *The Book of the Dead I*, New York 1972.
Flores	D. Flores, *The Funerary Sacrifice of Animals during the Predynastic Period*, Ph.d Dissertation, Department of Near and Middle Eastern Civilizations, Univ. Toronto 1999.
Fox 1975	M.W. Fox, 'Evolution of social behavior in canids', *The Wild Canids*, M. Fox (ed), New York 1975.
Fox 1978a	M.W. Fox, *The Dog, its Domestication and Behavior*, New York. 1978.
Fox 1978	M.W. Fox, 'Man, wolf and dog', *Wolf and Man: Evolution in Parallel*, R. L. Hall and H. S. Sharp (eds), New York 1978.
Frankfort	H. Frankfort, *Cylinder Seals*, London 1939.
Fuhr	I. Fuhr, 'Der Hund als Begleittier der Göttin Gula und anderer Heilgottheiten, Bayersiche Akademie der Wissenschaften, *Isin*-Išān Baḥrīyāt I, neue folge, heft 79, München 1977.
Galton	F. Galton, 'The first steps towards the domestication of animals', *Transactions of the Ethnological Society of London*, 3, 1868.
Goodman	G. Goodman (ed.), *The Saluqi, Coursing Hound of the East*, Apache Junction 1995.
Gowlett et al.	J.A. Gowlett, R. E. Hedges, I. A. Law & C. Perry, 'Radiocarbon dates from the Oxford AMS System: Archaeometry Datelist 5', *Archaeometry* 29, 1987.
Grattius	Grattius, *On Hunting*, J.W. & A.M. Duff, eds, *Minor Latin Poets*, vol. *I & II*, revised ed., 1935.
Grayson	D.K. Grayso, *Danger Cave, Last Super Cave, and Hanging Rock Shelter: the faunas*, Anthropological Papers of the American Museum of Natural History 66(1), New York 1988.
Green	A.R. Green, *Model Dogs, Catalogue 'Art and Empire'*, Metropolitan Museum of Art, New York, 1995.
Gwatkin 1933	R. Gwatkin, 'Dogs and human migrations', *The Journal of South African Medical Association*, 4, 1933.
Gwatkin 1934	R. Gwatkin. 'Dogs and human migration', *The Journal of South African Medical Association*, 5, 1934.
Handcock	P.S.P. Handcock, *Mesopotamian Archaeology*, London, 1912.

BIBLIOGRAPHY

Hall & Sharp — R. L. Hall & H. S. Sharp, *Wolf and Man: Evolution in Parallel*, New York 1978.
Harcourt — A. Harcourt, 'The dog in prehistoric and early historic Britain', *Journal of Archaeological Science*, 1 (1974), 1974.
Hauck — E. Hauk, 'Die Hunderassen im Alten Ägypten', *Zeitschrift für Hundeforschung* 16. Leipzig 1941.
Herodotus — *The Histories*, trans. A. de Selincourt, London 1971.
Hilzheimer 1908 — M. Hilzheirmer 'Beitrag zur Kenntnis der Nordafrikanischen-Schakale,' *Zoologica* 53, 20, 1908.
Hilzheimer 1926 — M Hilzheimer, *Natürliche Rassengeschichte der Haussäugetiere*, Berlin 1926.
Hilzheimer 1931 — M. Hilzheimer, *Zeitschrift für Hundeforschung*, Berlin, 1931.
Hilzheimer 1932 — M. Hilzheimer, 'Dogs', *Antiquity* VI, 1932.
Hull — D.B. Hull, *Hounds and Hunting in Ancient Greece*, Chicago 1964.
Al-Jahiz — Abu 'Uthman 'Amr b. Bahr al-Jahiz, *Kitab al-hayawan,* ed. 'Abd al-Salam Muhammad Harun, Cairo, 1938.
Janssen & Janssen — R. & J. Janssen, *Egyptian Household Animals*, Aylesbury 1989.
Jarman & Wilkinson — M. Jarman & P. Wilkinson, 'Criteria of animal domestication', *Papers in Economic Prehistory*, E. S. Higgs (ed), Cambridge. 1972.
King — L.W. King, *Babylonian Boundary Stones and Memorial Tablets*, London 1912.
Kozloff & Bryon — A. Kozloff & B. Bryon, *Egypt's Dazzling Sun. Amenhotep III and his World*, Cleveland 1992.
Lawrence 1967 — B. Lawrence, 'Early Domestic dogs', *Zeitschrift für Säugetier-kunde* 32, 1967.
Lawrence 1975 — B. Lawrence & C.A. Reed, 'The Dogs of Jarmo', in *Prehistoric Archaeology along the Zagros Flanks*, Chicago 1975.
Lichtheim — M. Lichtheim, *Ancient Egyptian Literature Vol. II: The New Kingdom*, Berkeley 1976.
Lloyd — S. Lloyd, F. Safar, 'Eridu', *Sumer* 4, 1948.
Lortet & Gaillard — L. Lortet & C. Gaillard, *La Fauna Momifiée de l'Ancienne Egypte* (série 4), Archives du Musée d'Histoire Naturelle de Lyons, Lyons 1903.
Macintosh — N. W. Macintosh, 'The origin of the dingo: an enigma', *The Wild Canids*, M. Fox (ed), London 1975.
Mallowan — M. Mallowan & J. Cruikshank Rose, 'The Excavations of Tell Arpachiya', *Iraq*, Vol. II, pt.1, London 1934.
Mathew — W. D. Mathew, 'Phylogeny of the dogs', *Journal of Mammalogy* II, no. 2, 1930.
McLoughlin — J.C. McLoughlin, *The Canine Clan*, New York 1983.
Möllers & Scharff — G. Möllers & L.Scharff, *Die Archaeologischen Ergebnisse des vorgeschichtlichen Gräberfeldes von Abusir el-Meleq*. Lepzig 1926.
Montet — P. Montet, *Everday Life in Egypt*, Philadelphia 1981.
Morey 1990. — D.F. Morey, *Cranial Allometry and the Evolution of the Domestic Dog*, Univ. of Tennessee. Ph.D. dissertation, Konxville 1990.
Morey 1992 — D. F. Morey. 'Size shape and development in the evolution of the domestic dog', *Journal of Archaeological Science*, 19, 1992.
Morey 1994 — D.F. Morey, 'The early evolution of the domestic dog', *The American Scientist*, 82, July/August 1994.
Morris — R. Morris, *Catalogue for the Man's Best Friend Exhibition*, Birmingham 1991.
Nemesianus — see Grattius above.
Newberry 1892 — P.E. Newberry, *El Bersheh I, The Tomb of Tehuti-hetep* London 1892.
Newberry 1893 — P.E. Newberry, *Beni Hasan I*, London 1893.
New York Times — Jasper Rine, *New York Times* 12.3.91 section B, 1991.
NH — Pliny, *Natural History*.

BIBLIOGRAPHY

,wak & Paradiso	R. M. Nowak & J.L. Paradiso, *Walker's Mammals of the World* I-II, London 1983.
Od.	Homer *Odyssey*.
Olsen	S.J. Olsen, *Origins of the Domestic Dog*, Tucson, 1985.
Oppian	Oppian, *On Hunting* ed. A.W. Mair, Cambridge Mass., 1928.
Osborn	D. J. & J. Osborn, *The Mammals of Ancient Egypt*, Warminster 1988.
Parrot	A. Parrot, *Revue d'Assyriologie*, Paris 1932.
Peet	T.E. Peet, *The Cemeteries of Abydos: Part II 1911-1912*, London, 1914.
Petrie	W.M.F. Petrie. *Diospolis Parve: The Cemeteries of Abadiyeh and Hu 1898-9*, London 1901.
Petrie & Quibell	W.M.F. Petrie & J. Quibell, *Naqada and Ballas 1895*, London 1896.
Phillips	A.A. Phillips & M.M. Willcock, *Xenophon & Arrian On Hunting*, Warminster 1999.
Pliny	*Natural History*, H. Rackham, W.H.S. Jones & D.E. Eichholz (eds), Cambridge Mass., (10 vols) 1938–.
Plutarch	*Plutarch* V (Isis and Osiris). F. Babbitt (trans.) Cambridge Mass. 1936.
Pollux	*Onomasticon* trans. in Hull above.
Przezdiezski	X. Przezdziecki, *Le Destin des Lévriers*, Nice, 2000.
Quibell	J. Quibell, *Hierakonpolis I*, London 1900.
Quibell & Green	J. Quibell & F. Green, *Hierakonpolis IV*, London 1900.
Real. IV	*Realllexikon der Assyrologie* IV, Berlin and New York, 1972-75.
Reed 1960	C.A. Reed, 'A review of the archaeological evidence on animal domestication in the Prehistoric Near East', in *Prehistoric Investigations in Iraqi Kurdistan*, Studies in Ancient Oriental Civilisations No.31, Chicago, 1960.
Reed 1969	C.A. Reed 'The pattern of animal domestication in the Prehistoric Near East', *The Domestication and Exploitation of Plants and Animals*. P. Ucko & G. Dimbleby, (edd.), Chicago 1969.
Savage & Long	R.J. Savage and M. R. Lon, *Mammal Evolution: an Illustrated Guide*, London 1986.
Schotté & Ginsberg	C.S. Schotté and G. Ginsberg, 'Development of social organization and mating in a captive wolf pack', *Man and Wolf*. H. Frank (ed), Dordrecht 1987.
Schweinfurth	G. Schweinfurth, 'Alte Tierbilder und Felsinschriften bei Assuan', *Zeitschrift für Ethnologie*, 44 1912.
Scott 1968	J.P. Scott, 'Evolution and domestication of the dog', *Evolutionary Biology*, 2, 1968.
Scott 1976	J. P. Scott, 'The evolution of social behavior in dogs ad wolves', *American Zoologist*, 7 1976.
Scott & Fuller	J. P. Scott & J. L. Fuller, *Dog Behavior: the Genetic Basis*, Chicago 1965.
Seal	U.S. Seal, 'Molecular approaches to taxonomic problems in the canidae', *The Wild Canids*, M. W. Fox (ed), New York. 1975.
Serjeant	R.B. Serjeant, *South Arabian Hunt*, London 1976.
Serpell 1989.	J. Serpell, 'Pet-keeping and animal domestication: a reappraisal', *The Walking Larder: Patterns in Domestication, Pastorlism and Predation*, J. Clutton-Brock (ed), London 1989.
Serpell 1995.	J. Serpel, *The Domestic Dog its Evolution, Behavior and Interactions with People*, Cambridge 1995.
Sillero-Zubiri	C. Sillero-Zubiri, 'A wolf in fox's clothing, *Geographical*, vol. LXX no. 5, London 1998.
Simonson	V. Simonsen, 'Electrophoretic studies on the blood protiens of domestic dogs and other canidae', *Hereditus* 82, 1976.
Simpson	W. K. Simson, *The Literature of Ancient Egypt*, New Haven 1973.

Smith	G.R. Smith, 'The Arabian hound, the Salūqī –further consideration of the word and other observations on the breed', *Bulletin of the School of Oriental and African Studies*, vol. XLIII, part 3, London, 1980.
Stager	L. Stager, 'Why were hundreds of dogs buried at Ashkelon?', *Biblical Archaeological Review* 17, 3, 1991.
Stein	Herodotus, *Histories*, H. Stein (ed.), Berlin, 1883.
Strabo	*Geography*, H.L. Jones (ed), 8 vols, Cambridge Mass., 1917-32.
Symons	D. Symons, *Man's Best Friend*, Birmingham, 1991.
Tchernov & Horwitz	E. Tchernov & L. K. Horwitz, 'Body size diminution under domestication: unconscious selection in primeval domesticates', *Journal of Anthropological Archaeology*, 10, 1991.
Tchernov	E. Tchernov & F.F. Valla, 'Two new dogs and other Natufian dogs, from the Southern Levant', *Journal of Archaeological Science*, 24, 1997.
Tedford	R. H. Tedford, 'Key to the Carnivores', *Natural History*, 103:4 1994.
Tobler	A.J. Tobler, *Excavations at Tepe Gawra*, II, Philadelphia 1950.
Turnbull & Reed	P.F. Turnbull, C.A. Reed 'The fauna from the terminal Pleistocene of Palegawra cave', *Fieldiana Anthropology* 63, 1974, 3.
Van Buren 1939	E.D. Van Buren, 'Fauna of Ancient Mesopotamia as Represented in Art' *Analecta Orientalia*.18, Rome, 1939.
Van Buren 1931	E.D. Van Buren, *Foundation Figurines & Offerings*, Berlin 1931.
Varro	*On Agriculture*, see Cato above.
Wapnish & Hesse	P. Wapnish & B. Hesse, 'Pampered pooches or plain pariahs? The Ashkelon dog burials', *Biblical Archaeology* 56, 2, 1993.
Ward	P. Ward, *Travels in Oman*, Cambridge 1987.
Waters	H. & D. Waters, *The Saluki in History, Art & Sport*, 2nd ed., Hoflin Publishing Ltd, Wheat Ridge, Colorado, 1984.
Wayne 1986a	R.K. Wayne, 'Cranial morphology of domestic and wild canids: the influence of development on morphologic change', *Evolution* 40, 1986.
Wayne 1986b	R.K. Wayne, 'Limb morphology of domestic and wild canids: the influence of development on morphological change', *Journal of Morphology* 187, 1986.
Wayne 1993	R.K. Wayne, 'Molecular evolution of the dog family', *Trends in Genetics* 9, 1993.
Wayne 1997	C. Vila, P. Savolainen, J.E. Maldonado, I.R. Amorim, J.E. Rice, R.L. Honeycutt, K.A. Crandall, J. Lundeborg, R.K. Wayne 'Multiple and Ancient Origins of the Domestic Dog', *Science*, Vol. 276, 1997.
Werth	E. Werth, 'Die primitiven Hunde und die Abstammungsfrage des Haushundes', *Zeitschrift für Tierzüchtung und Züchtungsbiologie* 56, 1944.
Winkler	H. Winkler, *Rock-Drawings of Southern Upper Egypt* I-II, Oxford 1938.
Wolfgram	A. Wolfgram, 'Die Einwirking der Gefangenschaft auf die Gestaltung des Wolfsschädels', *Zoologische Jahrbücher* 3, 1894.
Xenophon	*On Hunting*, see Phillips.
Zeuner	F.E. Zeuner, *A History of Domesticated Animals*, London 1963.

Index

Abadiyeh 28
Abydos burials 44
Adad-apla-iddina, King 54
Aesculapius 55
African hunting dogs 6, 9, 10, 13, 16, 17, 18
Alexander the Great 72, 95
Althiburos 99
Antef II, tomb of 43
Anubis 29, 45
Argus 84
Artemis / Diana 97
Ashdod 54
Ashurbanipal's 58-9, 65, 95
Askelon 54
asses, see onager

Babylon 56, 58, 72, 73
Badari 28
Basenji 1
bears 5, 6, 7
Bel-salti-nannar 65
Birs-Nimrud 56
Bismaya 71
boar, boar hounds 60, 66, 77, 82, 86, 87, 88, 90, 99, 102
Bonn-Oberkassel 24
Boojy 71
Bosra 76, 77
breed, definition of 25-6, 83
British dogs 3, 85

Cambyses 58, 60, 72
camels 5
canis familiaris Studer 56, 61-7
Carthage 92, 93, 99
Castorian hound 83, 88
cats 1, 6-7, 23, 45, 53
Celtic hound see vertragus
Chenemhotep, tomb of 36
Chihuahua 1, 5, 49,
classical breeds, list 103
Collie 92, 102
coursing hounds, see sighthounds

coyote 9, 10, 13, 16, 17, 18, 19, 21
Cretan hounds 88
Cynopolis, rites 45
Cyrus 58, 72

Danger Cave 24
deer 58, 88, 102
dhole 9, 12, 13, 16, 17,
dingo 9, 11
diseases of dogs 97-8
Döbrita-Kniegrotte 24
dog deities, see Anubis, Wepwawet

ears, cropped 68, 70
eating dogs 44, 53, 54, 95
Ekbash, see Karabash
Elam-dog 71
El Djem 81, 82
equipment for dogs, *inc.* leads etc 99-100
Eridu 53
Etana 61

Farah 71
foxes 6, 7, 16, 53
 kit 19,
 bat-eared 19

gazelle 58
genes (*inc.* DNA etc) 4, 5, 18-20, 25, 26, 34, 39, 50, 102
German shepherd dog 34, 49
goats 68, 69
Greyhound 1, 40, 42, 43, 53, 58, 68, 78
guard-dogs, see shepherd dogs
Gudea, and family 65
Gula 54-5, 61, 70
gun-dogs 71, 102

hares 53, 77, 89
Hayonim Cave 52
Hecate 58, 65

Heliopolis 28
Hemaka, tomb of 33
Hierakonpolis 37
horses 5
Huarte 77
Husky 50
hyenas 6, 7, 74

Ibbi-Sin, King 71
ibex 74, 75
Inat 74
Indian dogs 58, 72, 85, 88, 95
Irish wolfhound 1, 15,
Isin 54

jackals, Black-backed 11,
 Golden 9, 13, 15, 16, 17, 18, 19, 45, 46
 Simien, see wolves
Jaguar Cave 24
Jarmo 50-1
Jawan Singh, Mahrana 60

Karabash 58
Khafajeh 71
Kish 65, 71
kudurru 61-2
Kuyunjik 68
Kuvasz 78

La Chebba 88
Laconian hound 73, 83, 84, 86, 88, 90
Lagash 56, 65
lap-dogs 40, 43, 44, 82, 93-4, 102
leopard 95
lion 58, 95
Locrian hound 88
lynx 58

Maadi 28
Mahasna 28
Malkata 66
Mallaqha 51
Maltese, see Melitean

CHAPTER III: ANCIENT EGYPTIAN DOGS

Mari 72
mastiffs, *see also* Molossian hound, Tibetan dog etc 37-8, 49, 55, 56-60, 65, 72, 78, 92
Matara 75
medical uses of dogs 44
Medina 77
Melitean dog 85, 86, 94, 102
Meluhla 71
Mereruka, mastaba of 36
Merimde 28
mesocyon 5, 6, 8
metagon 95-6
miacids 5, 6, 8,
Minshat Ezzat 37
Molossian hound, 81, 86, 87, 90, 102
mongrels 39, 40, 41, 42, 43, 44, 45, 46, 66, 67, 75, 78, 87
Mostegga 28
Mukhayat 76
mummies, dog 30

Nabnodius 62, 65
Nag ed Der 28
names, dog, Assyrian 65
 classical 101
 Egyptian 43
Nebo, Mount 76, 77
Neferhotep, tomb of 37
Newfoundland 91
Nineveh 58, 62, 65, 68, 72, 78
Nin-isina, *see* Gula

onager 58
oryx 77
ostrich 31
Oudna 63

Palegawra Cave 23, 50
Panormus 55

pariahs, *see* mongrels
Pekinese 49, 78
Pergamum 58
Peritas 95
Persepolis 57-8
pet-dogs, *see* lap-dogs
pointer 78
police dogs 43
Pomeranian 66, 71
Pompeia, stela of 87, 94
Pompeii 82, 86, 87, 90, 92, 102
pug 78

Qermez Dere 52-3

racoons 5, 6, 7, 19
Radmea, tomb of 37
rock drawings 2, 28, 31, 32, 33, 74

St Bernard 15,
Saluki (*also* sloughi) 1, 3, 33-5, 40, 42, 43, 52, 53, 55, 56, 58, 60, 63, 64, 66, 67, 68-70, 71, 72, 73, 74, 75, 76, 77, 78, 79, 81, 82, 89, 94, 102
Seckenberg 24
Seleucus 73
Sennacherib 78
shepherd dogs 1, 26-7, 56, 60-1, 66, 71, 78, 84, 90-3,
Shimal 53
Shiraz 74
short-limbed dogs 36-7
sight-hounds (*see also* Greyhound, Saluki etc) 3, 26, 32-5, 40, 41, 43, 49, 67-70, 88
Sippar 61
slips 56
spaniel 1
Starr Carr 23, 24

Sumu-la-ilu, King 56
Susa 68, 70

Tehutihetep, tomb of 36
Tell Abu Shahrain 53
Tell Aqrab 70
Tell Arpachiya 68
Tell Brak 53
Tepe Gawra 53, 68, 79
terriers 56, 71
Tesem 29, 32-3, 40, 41, 42
Tibetan dogs 58, 60, 85
tigers 95
Tiryns 66
tomarctus 5, 6, 8
Torfhund 71
Tutankhamun, tomb of 34, 35, 94

Ur 62, 65, 72
User, tomb of 35

vertragus 88-9, 90
Vulci 85
Vulpine hounds 88

Wadi Digla 28
Wadi Hadhramawt 75
Wadi Judayyid 74
war-dogs, 1, 26, 58, 94-5
Warka 71
weasels 5, 6, 7
Wepwawet 46
Whippets 87
wolves, Arabian 21, 23, 50, 51, 52, 68, 79
 Grey 2, 5, 9, 13-18, 19, 20, 21-23, 26, 28, 42, 49, 50, 91, 102
 Indian 50, 58-60,
 Red 16, 18
 Simien 19, 50